The Scrapbooker's Color Palette
Using Color To Create Fabulous Scrapbook Pages

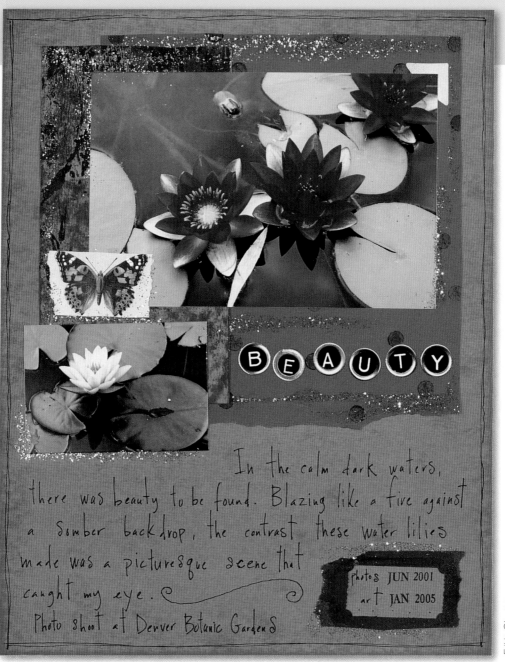

BEAUTY

In the calm dark waters, there was beauty to be found. Blazing like a fire against a somber backdrop, the contrast these water lilies made was a picturesque scene that caught my eye. Photo shoot at Denver Botanic Gardens

photos JUN 2001
art JAN 2005

Erikia Ghumm

cantata books · LARK BOOKS

EDITOR
Kerry Arquette

ART DIRECTOR/DESIGNER
Andrea Zocchi

COVER DESIGN
Barbara Zaretsky

CONTRIBUTING WRITER
Lois Duncan

EDITORIAL SUPPORT
Anne Stroud
Kim Saltiel

WE'D LIKE TO THANK

our families and dear friends who supported us during the creation of this book—Cantata's first child! Thanks also to the artists who allowed their creative visions to flood these pages.

Created and produced
by Cantata Books Inc.

P.O. Box 740040
Arvada, CO 80006-0040

www.cantatabooks.com

10 9 8 7 6 5 4 3 2 1

First Edition

Published by Lark Books, A Division of
Sterling Publishing Co., Inc.
387 Park Avenue South, New York, N.Y. 10016

Distributed in Canada by Sterling Publishing, c/o Canadian Manda Group,
165 Dufferin Street, Toronto, Ontario, Canada M6K 3H6

Distributed in the U.K. by Guild of Master Craftsman Publications Ltd.,
Castle Place, 166 High Street, Lewes, East Sussex, England BN7 1XU
Tel: (+ 44) 1273 477374, Fax: (+ 44) 1273 478606, "email": pubs@thegmcgroup.com,
Web: www.gmcpublications.com

Distributed in Australia by Capricorn Link (Australia) Pty Ltd.,
P.O. Box 704, Windsor, NSW 2756 Australia

If you have questions or comments about this book, please contact:
Lark Books, 67 Broadway, Asheville, NC 28801. Tel: (828) 253-0467

Manufactured in China

ISBN 1-57990-727-x

For information about custom editions, special sales, premium and corporate purchases, please contact Sterling Special Sales Department at 800-805-5489 or specialsales@sterlingpub.com.

Introduction

Color theory. Tertiary colors. Saturation. THE COLOR WHEEL.

Words intimidating enough to make a strong woman cower. But before you bail on us, hear our vow: "We solemnly swear that this is one color-concepts book that won't activate a single scary goose bump. Neither will it put you to sleep nor make you feel like you are back in your elementary school art class studying why color works when all you really wanted to do was paint a picture of your mom."

Like you, we understand the agony of plowing through dry text detailing the "this" theory and the "that" concept, when the Siren's call to race to the store and scoop up candy-colored scrapbooking papers, juicy stickers and lush inks sings so loudly in your ears that you can barely think. And so, within *The Scrapbooker's Color Palette*, we've tried to give you a fun (and colorful) reading experience while we share gobs of both useful and utterly worthless (but interesting) information about color.

Yes, *The Scrapbooker's Color Palette* will educate you about color concepts. It will also offer fail-safe color combinations that will help you create stunning pages. You'll also discover unusual color combinations that will have you scratching your head wondering, "How did the artist know that putting those colors together would result in a scrapbook page so beautiful and full of emotion?"

So, just for an hour or two, set aside your colored pencils, your rainbow of scrapbooking papers, inks and other colorants, and snuggle up with a good book (yes, we are talking about this one!). When you finish the last page, you may see the world through a very different prism. And your scrapbook pages will reflect the journey you've taken.

Kerry & Andrea

Kerry and Andrea

Founders of Cantata Books Inc.

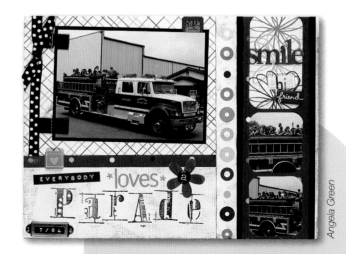

Angela Green

Table of Contents

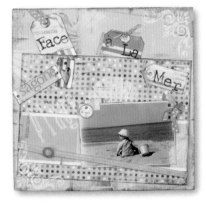

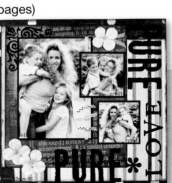

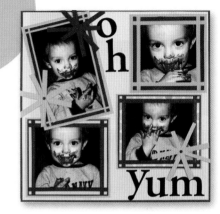

Color Basics for Scrapbookers
the wheel, color theory, color combinations and inspiration

A rainbow—child of sunlight and a watery sky

The perfect chaos of a preschooler's finger painting

Melting sprinkles swirled into vanilla ice cream

Color magic

BASIC

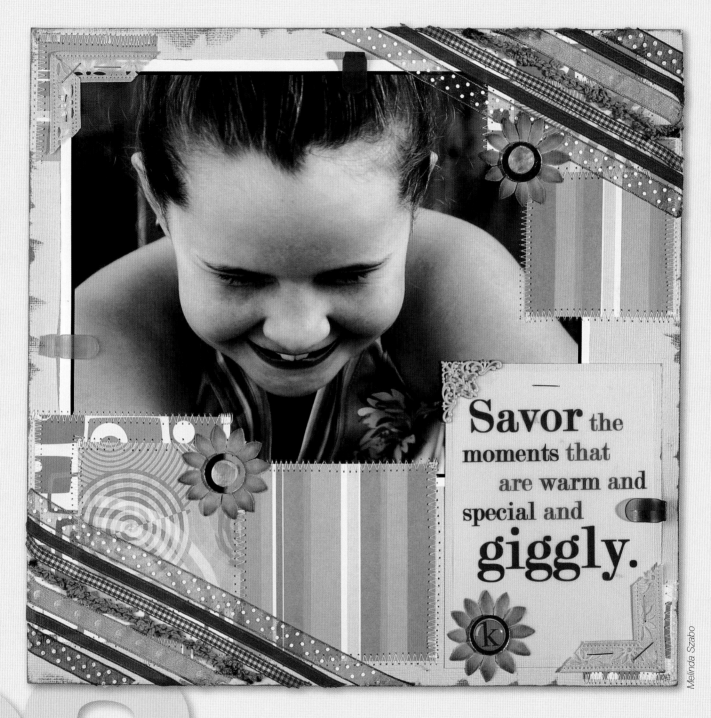

Savor the
moments that
are warm and
special and
giggly.

Melinda Szabo

Scrapbooking's Colorful Supplies

Every artist needs her supplies in order to create, and the supplies available to today's scrapbooker are virtually unlimited. Whether looking for products to form a background for a spectacular page, colorize page elements for interest and dimension, or add an embellishing flourish, you are sure to find the right materials to mix and match for utterly unique pages. Simply customize the products to suit your own taste and style, add heartfelt journaling, and you'll have a piece of artwork that will be cherished for years.

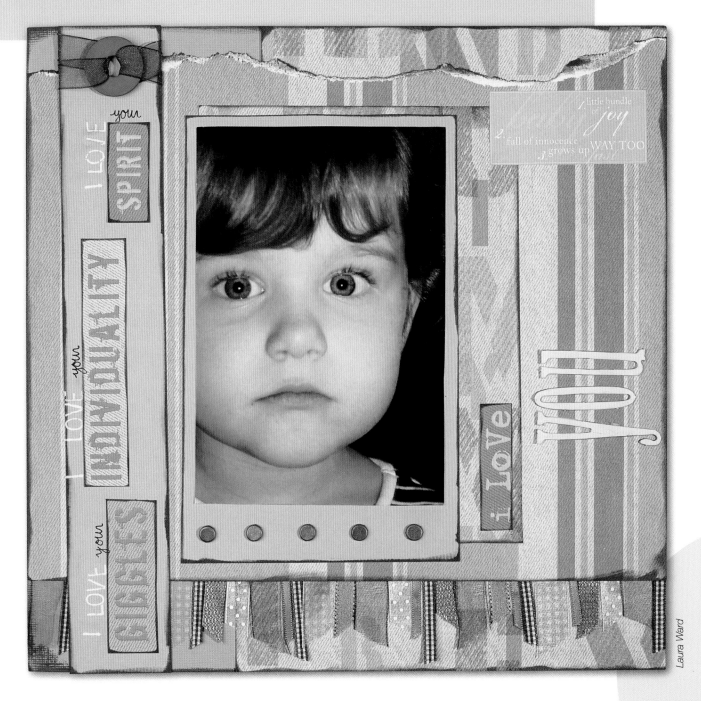

Laura Ward

PAPER

Scrapbook paper is available from scrapbooking, craft, hobby, big box, and chain stores. It can be bought and sold online and through scrapbooking clubs or acquired through crop swaps. Basic cardstock can be found in every color and texture imaginable. Like cardstock, patterned papers come in themes from A (alphabet) to Z (zany). They include delicate florals and bold prints in a wide range of palettes. For those looking for a quick and easy solution to color selection, many patterned paper lines are designed to coordinate. In addition, you may choose from speciality papers including mulberrys, metallics, velvets, handmade papers and many more. Purchase paper in bulk or by the piece. With the range of paper currently available, there is a palette for every scrapbook page.

COLORANTS

Colorants are an easy way to alter the color of scrapbook paper, mats, photos, and embellishments. Paints, from watercolor to acrylic, can be daubed on paper, fabric, and ribbon page elements or other embellishments. Used along a sanded edge of either a photo or paper page element, chalk and rub-ons add a border that helps pop the photo from the page. Subtle chalking of paper page elements adds dimension and complexity. Stamping inks can create complex customized patterned papers, page titles, and journaling, as well as intricate embellishments. The wide range of pencils and markers makes it possible to create page titles, journaling, and hand-drawn details in any shade known to man.

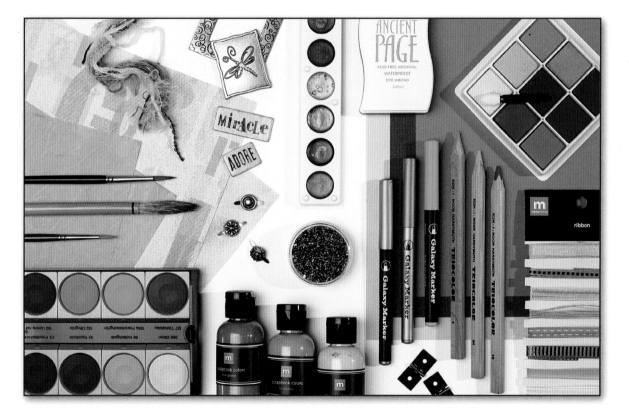

EMBELLISHMENTS

Whether strung through colorful eyelets, wrapped around photo mats, or woven through elaborate borders, fibers, ribbons and other textiles are one of the easiest ways to introduce a complementary or contrasting color to a scrapbook page. Beads and baubles, strung upon floss and stitched to a page, or adhered decoratively to page elements, create an "evening out" feeling that can be reinforced with colorful snaps and brads. Metallic embellishments including frames, clips, photo corners, and charms contribute gleam in gold, copper, and silver hues. From sweetly simple to cunningly complex, stickers and die cuts add their own colorful statement to the finished product.

The Nitty Gritty Facts About Color

Color theory doesn't have to be scary or boring. In fact, by understanding just a few basic concepts, you can learn to mix and match colors like a pro. All the colors we can perceive are created by mixing the three primary colors—red, blue and yellow. By mixing and remixing those essential hues and their offspring, you can create all the colors of the rainbow and more.

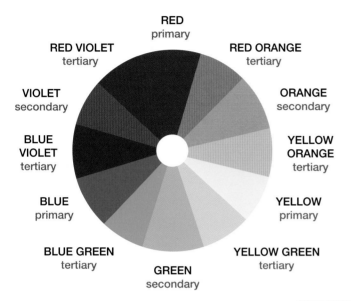

RED
primary

RED VIOLET
tertiary

RED ORANGE
tertiary

VIOLET
secondary

ORANGE
secondary

BLUE VIOLET
tertiary

YELLOW ORANGE
tertiary

BLUE
primary

YELLOW
primary

BLUE GREEN
tertiary

YELLOW GREEN
tertiary

GREEN
secondary

THE WHEEL

It was Sir Isaac Newton who developed the first color wheel in 1666 when he divided a circular shape into seven color segments. The center of the wheel was white, which Newton believed contained all colors. Over the centuries the wheel has evolved as scientists and artists have grown to understand and evaluate color theory from different perspectives. However, the wheel, in all its variations, continues to provide the same service for artists, who use it to reference color combinations and make the strongest color choices possible for their work.

Primary Colors

The basic colors on any color wheel are those labeled "primary." These colors—red, yellow and blue—cannot be created by mixing any other color combinations. Primary colors are essentially the paint pot from which all other colors are created.

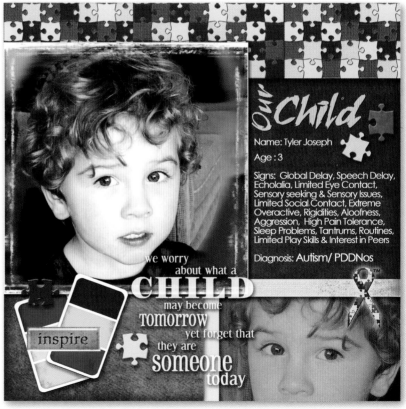

One Child

Name: Tyler Joseph

Age : 3

Signs: Global Delay, Speech Delay, Echolalia, Limited Eye Contact, Sensory seeking & Sensory Issues, Limited Social Contact, Extreme Overactive, Rigidities, Aloofness, Aggression, High Pain Tolerance, Sleep Problems, Tantrums, Routines, Limited Play Skills & Interest in Peers

Diagnosis: Autism/ PDDNos

we worry about what a CHILD may become TOMORROW yet forget that they are SOMEONE today

inspire

Rachel Dickson

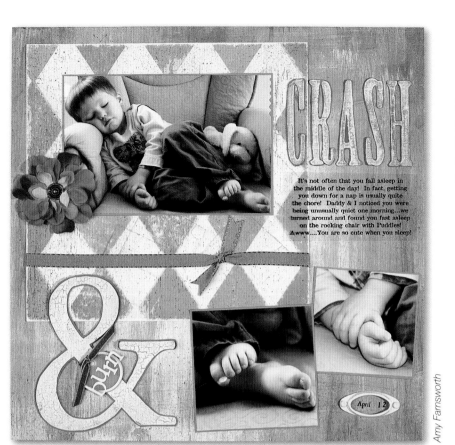

Amy Farnsworth

Secondary Colors

By mixing only the three primary colors, it is possible to create the additional hues of green, orange and violet. These are the secondary colors on the color wheel.

Tertiary Colors

Tertiary colors are formed by mixing a primary color with a single secondary color. Yellow-orange, red-orange, red-purple, blue-violet, blue-green and yellow-green are tertiary colors.

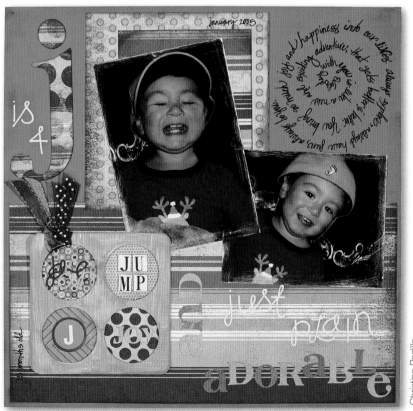

Christina Padilla

Color Harmony

Selecting hues that work well together and convey a determined mood and message is a challenge for many artists. Choosing a poor accent color can transform an otherwise spectacular scrapbook page into a blooper. There are some tried and true formulas, however, to help assure success when mixing it up.

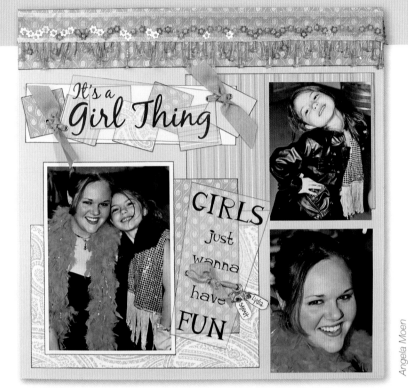

Angela Moen

Monochromatic Color Schemes

This color palette uses variations in lightness and saturation levels of a single color to create artwork. The scheme is easy to use, and scrapbook art created in a monochromatic scheme often looks elegant and classic.

Complementary Color Schemes

Complementary colors are any two colors that are found opposite each other on the color wheel. These opposing colors, such as red and green or blue and yellow, are used to create artwork with maximum contrast. When using complementary color schemes, it is best to select a principal color and use the complementary color as an accent.

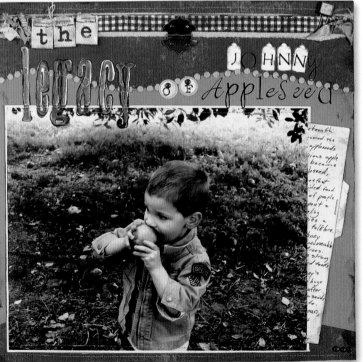

Pam Callaghan

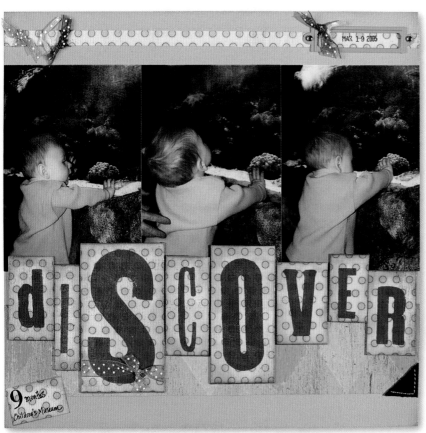

Leah Zion

Split-Complementary Color Schemes

When using a split-complementary color scheme, hues are selected by determining a principal color and its complementary color. The colors adjacent to the complementary color are the split-complementary colors. When used in artwork, this color choice often offers a more interesting palette than a straight complementary scheme.

Analogous Color Schemes

An analogous color scheme is based on a combination of two or more colors which can be found side-by-side on a color wheel. Most often, one of the colors in this scheme is used as the primary hue and the adjacent colors are used to add interest to the palette as accents.

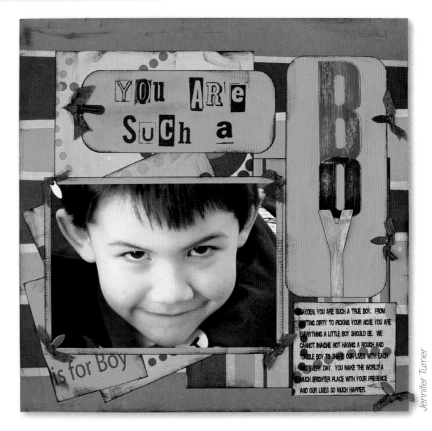

Jennifer Turner

13

Saturation and Value

Selecting the just-right colors to use on a scrapbook page is just the beginning of color selection. The intensity of those colors can determine if the artwork will be viewed as gentle or robust, More robust colors tend to be heavily saturated, giving the shades a deep, rich feeling. The value of the color can also vary, from light to dark, impacting the mood of the palette. Keep both saturation and value in mind when reaching for your papers to ensure artwork that shows it knows and speaks its mind.

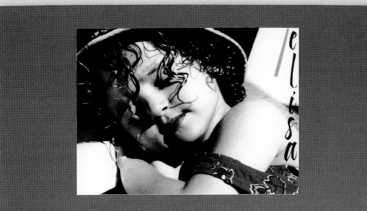

Saturation

Saturation is described as the amount of gray present in a hue. The same hue can take on a very different feeling if the saturation of the colors are varied. The more gray, the less saturated the color. The less gray added to a hue, the bolder, richer and fuller the color will be. Take a look at the difference saturation makes to the same piece of artwork. The page on top is more heavility saturated than the version below.

Prisca Jockovic

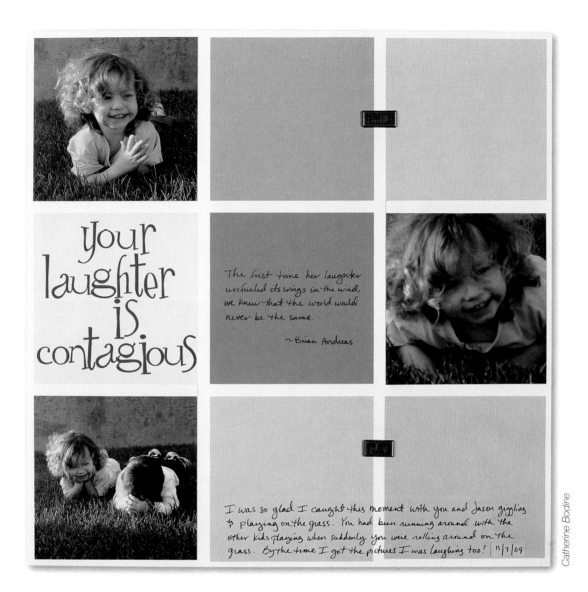

your laughter is contagious

The first time her laughter unfurled its wings in the wind, we knew that the world would never be the same.

~ Brian Andreas

I was so glad I caught this moment with you and Jason giggling & playing on the grass. You had been running around with the other kids playing when suddenly you were rolling around on the grass. By the time I got the pictures I was laughing too! 11/7/04

Catherine Bodine

Value

Value is the lightness or darkness of a color. Lighter color values are called "tints," while darker color values are called "shades." Those values that lie somewhere between are called "midtones." Pastels, for example, might be referred to as "tints." All colors can vary in value. Mixing colors of different value can create contrast, while pages that are built around palettes of colors with similar values can appear balanced and calm.

The swatches to the left demonstrate a change in value from dark to light. Note how the color goes from the darker "shade" to the lighter "tint."

Color's Effect on Your Body

Feeling a case of the sniffles coming on? Feeling down in the mouth or just too darned tired to scrapbook today? Maybe what you need is a dose of color to set things right. Color and light have been used to affect the body's health since the beginning of recorded time. It is believed that Ancient Egyptians built special rooms with colored glass through which the sunlight shone onto an ailing patient. Other treatments included wrapping patients in colored cloths.

"Chromotherapy," the practice of using color to improve ailments ranging from sore muscles to stroke, jet lag to depression, continues today. Specialists often practiced in conjunction with other holistic arts, manipulating colors to balance the energy in a client, utilizing crystals, direct light, colored cloth and, even colored contacts.

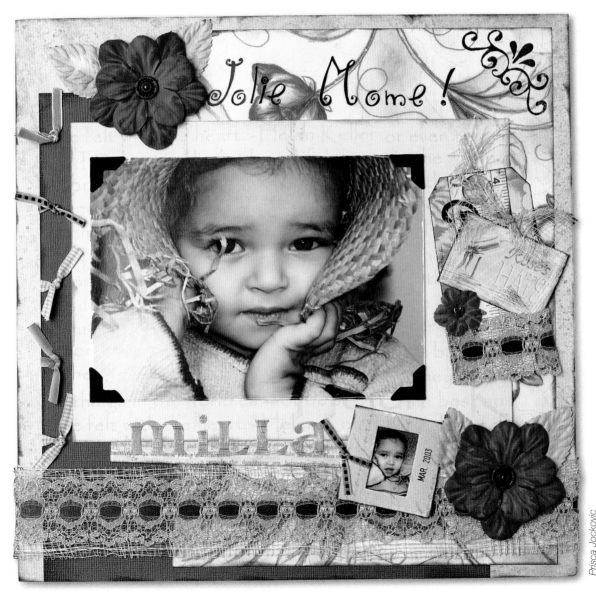

Prisca Jockovic

HOW DOES COLOR DO THAT?

Light is the primary energy source on earth, and color is derived from light. Our body absorbs and uses the energy that comes from light and the unique energies from different colors of light. Colored light stimulates the pituitary and pineal glands and triggers hormone production. That sets off a whole chain of reactions that can impact the way your body is functioning.

COLORS AND CURES

RED Oh baby, red is hot. As a healing color, it stimulates the heart rate, increasing body temperature, thereby affecting hormone levels and sexual desire. Chromotherapists might use red to correct anemia, low blood pressure and lethargy.

ORANGE Yum. Orange can be used to stimulate the appetite and the immune system. Some practitioners use it to reduce pain. While orange can help treat depression, it can also send hypersensitive or stressed out folks into a nervous fit. Serve sparingly.

YELLOW Ever felt muddled? Just kinda out of it? Yellow may be the cure for the fog that bit you. It is used to fight depression and also for digestive problems, headaches and joint disorders. Like orange, a little yellow can go a long way.

GREEN Think of flopping back on a velvet lawn under a leafy tree. Ahhhh. Calm, cool green is the color of balance and is used to treat people with heart and blood pressure concerns. It helps create peace, (but is also believed to grow things like tumors; healers say to avoid it if you are worried about that type of illness).

BLUE Floating in an ocean of blue, blue water can make anybody sleepy. So it's no surprise that practitioners use blue to treat insomnia and blood pressure problems as well as to reduce tumors, fevers and infections. Turquoise is used to treat inflammation and give the immune system a kick while dark blue is used to reduce out-of-control bleeding and to strengthen the immune system, ears, eyes, nose and mouth.

PURPLE Deep, lush, consuming purple cannot be ignored; it stands out even when it's standing back. A favorite of the psychedelic 60s, this royal color carries clout with healers, who turn to it to treat cancer, arthritis and nervous disorders.

Yes, you've got it right... this is that official disclaimer !

Let it be noted that we are not MDs, PhD's or any other important types of folk. We are just starving editors, designers and artists who have heard about these theories from various sources. While color may improve health, we strongly encourage you to see your primary care provider should you be ailing. It is always better to be safe than sorry. And we would be very sorry to hear from one of those other important folks who get to use initials behind their names such as ESQ.

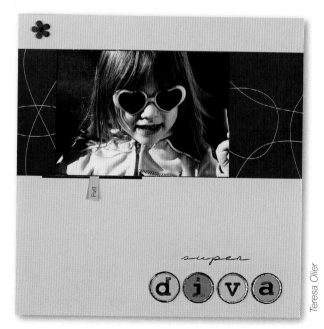

super
d j v a

Teresa Oller

The Emotional Impact of Color

Ever felt "blue," or perhaps "green" with envy? Maybe you see "red' when you're spitting angry? The connection between color and emotion has long been recognized. Good artists need to understand which colors best convey particular emotions. In doing so, we are less likely to simply draw palettes from colors in our photos without considering the impact they have upon our emotional intent. By utilizing appropriate colors in artwork, you can convey your own emotions about the layout and also engage viewers in that emotional moment.

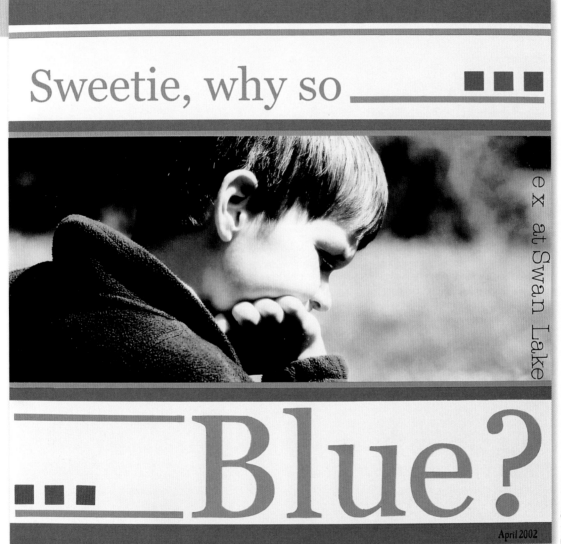

Sweetie, why so ___ Blue?

ex at Swan Lake

April 2002

Trudy Sigurdson

Common Color and Mood Associations

Blue: sad, prayerful, restful, masculine
Red: angry, passionate, forceful, cautious
Orange: happy, ambitious, hungry, warm
Green: envious, miserly, hopeful, youthful, tranquil
Purple: powerful, omnipotent, holy, mystical

Pink: feminine, healthy, young, vibrant
Yellow: giddy, joyful, fresh, acerbic
Black: exotic, dangerous, ill, scary, dominant
White: clean, new, airy, pure, empty, virginal

USE A GENTLE TOUCH

While colors are the perfect way to express your emotions about scrapbooked events, the selected colors don't have to be splashed wildly across your page. In fact, a subtle use of just the right color is often much more interesting. Remember that "more isn't necessarily better" when it comes to color, so choose carefully and cleverly.

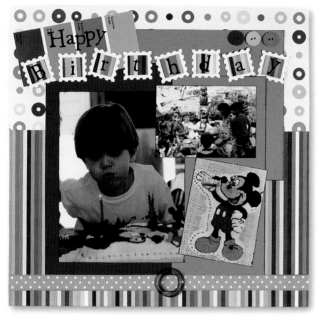
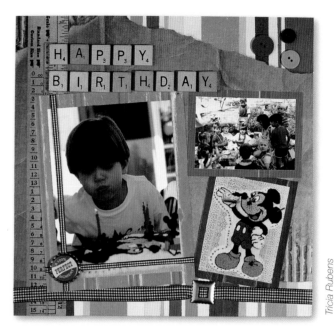

Tricia Rubens

Happy Birthday

Blow-'em-out-of-the-water primaries are a staple for birthday pages. However, a palette of earth tones may allow photos and journaling to pop visually. Splashes of primary accent colors add just enough celebratory energy.

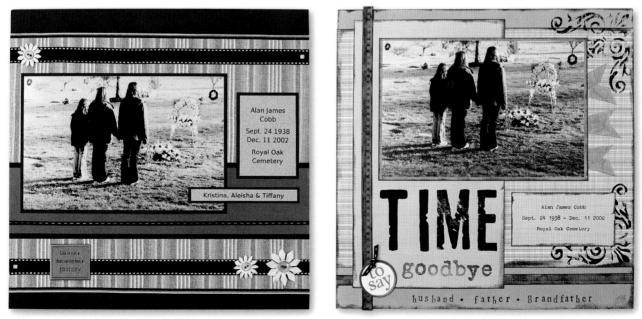

Trudy Sigurdson, Photos: Karen Cobb

Time To Say Goodbye

Darker colors may seem the obvious choice when scrapbooking loss, but dipping a page in black isn't going to convey mourning any better than judicious use of less somber colors.

Determining the Mood for Your Scrapbook Page

Every piece of art conveys a mood that moves viewers emotionally. When you are having trouble defining the mood for your scrapbook page, it may be because you are unclear about the mood you wish to convey. Just as actors are coached to act out a single clear emotion in response to their scene, your pages will be stronger if you settle on a single mood. If you have trouble settling on the right mood, pretend to be an actor yourself. This is your big scene—your chance to utterly steal the show. But, in order to sway the audience, you first have to understand what your character is truly feeling about being a part of this scene. Because you cannot play more than one feeling at a time, you must choose between, for example, "anger" and "boredom" (to play the emotions at the same time would equal "angdom" and what the heck is that?!) So pick photos and settle on a single mood. Then select colors, a design and embellishments that convey that mood as clearly as possible. Those who admire your pages will feel the impact of your conviction.

Goofy Girl

Acting Goofy while waiting for Sierra to march with the baton group in the PSU 2003 Homecoming Parade.

Cathi Lindsay

Colorful Words

Narrow down the mood of your scrapbook page by selecting a word that best describes it. Close your eyes. Repeat the word three times. What colors spring to mind each time you say the word? These colors may be the very ones you need to best suit the mood of your artwork.

Admiration	Desire	Exhilaration	Horror	Pity	Shame
Adoration	Despair	Expectation	Humiliation	Pride	Shock
Amazement	Desperation	Fascination	Hysteria	Rage	Sorrow
Ambition	Determination	Fear	Impatience	Regret	Spookiness
Anger	Disappointment	Frustration	Indifference	Relief	Suspicion
Anticipation	Disbelief	Greed	Indignation	Remorse	Sympathy
Anxiety	Disgust	Grief	Jealousy	Resentment	Terror
Awe	Eagerness	Guilt	Joy	Respect	
Boredom	Embarrassment	Happiness	Loneliness	Revenge	
Compassion	Envy	Hatred	Lust	Sadness	
Curiosity	Exaltation	Hope	Mischief	Serenity	
Defiance	Exasperation	Hopelessness	Panic	Sexiness	

PLAY THE ESSENCE GAME

"Essence" is the property that serves to characterize or identify something. The essence of a person or place is often elusive, but by keying into it, you can help describe the subject's special and very unique qualities. Essence can be expressed by color. In fact, determining the essence of a subject can lead to unusual and successful color choices that truly speak to the topic. Help refine your own abilities to identify the essence of a subject by playing the Essence Game (see rules below).

How to play: Gather a group of friends. Select one person to be the "Asker." Send him from the room. When the "Asker" is gone, choose an "It" from among those players remaining.

The asker's task: To determine who is "It" by asking any of the group members three essence questions.

Questions: Ask questions in the following manner: "If the "It" were a _____, what would he be?" (Example: "If the "It" were a gemstone, what would she be?" Answers might include, "ruby," "diamond," "emerald," etc.)

To win: The "Asker" must guess who the "It" is. If right, he rejoins the group. If wrong, he sits out the next round.

Essence Themes

Consider the following words to insert in the blank when playing the Essence Game: *animal, color, song, art form, car, type of shoe, type of dance, sound, musical instrument, season, accent, foreign country, nail polish color, decade, famous painting, Broadway musical.*

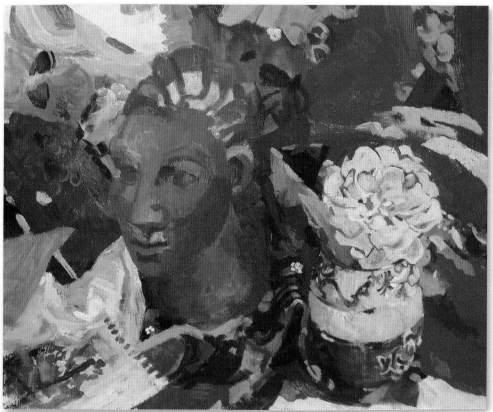

Painting by Megan Williamson-Crowell

Color Exercise for the Eye & Mind

Examine the painting above. Use a word from our "colorful words list" to determine a mood for the painting. How does the painting convey this mood in the choice of color (not subject)? Are the color choices cool or warm? Are the colors popularly associated with different moods? How has the painter used the color to create light play across the scene? How has that affected the mood of the painting?

Understanding Your Color Preferences

"What's your favorite color?" It's a question we're asked over and over again from the time that we are very young. Our favorite color seems to say so much about who we are that family, friends and teachers use the information to better understand our personalities. We tend to be drawn to favorite colors because they trigger emotions within us that make us happier. Certain colors make us feel excited, restful or safe, and we gravitate toward those shades that meet our emotional needs. But, strange as it may seem, what we commonly identify as our "favorite colors" may not be the shades we are actually most strongly drawn toward. This is because the colors that call to us and our needs at certain points in our life, are not those that fulfill our needs as we evolve. Discover your true favorite colors with the exercise below, and you'll know yourself a little better.

YOUR COLOR PATTERNS

Begin with a jumbo pack of crayons—the more color options you have, the better. Cut two white sheets of paper into quarters. On each of the pieces of paper write one of the following words: joy, sadness, anger, love, cold, hot, windy, fair. Next, quickly color free-form pictures to illustrate the emotional vibrations of each word. Simply try to capture in a few strokes the feeling that you get from each word. When finished, spread out your work. Do you see patterns emerging in your color choices? If so, you may better be able to identify those colors that will translate into scrapbook pages that will emotionally move you. By identifying personal color preferences, you may also be better able to step back when selecting color schemes and ask yourself, "Does the color palette under consideration do justice to the photos and themes of this scrapbook page, or am I trying to impose my favorite color on a page that might benefit from a different hue?"

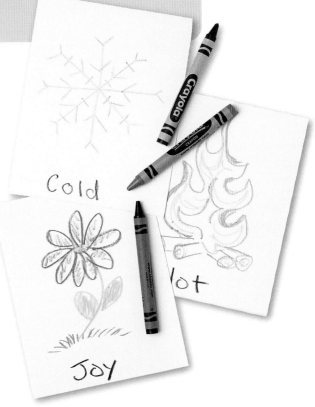

Cathi Lindsay

Color Forecasting and Fashion

As early as the turn of the century, color trends in the fashion industry have been set by the movers and shakers of the apparel and textile industries. Some of the earliest were the milliners (hat makers) who issued seasonal color forecasts. In 1915 color forecasting was picked up by the Textile Color Card Association, in New York City. The Association is still in business today and is joined by many other color forecasting agencies, design publications and individual designers who collectively decide what color will be "in" this coming season.

Shannon Bastian

PEEK IN YOUR CLOSET

It all began with that pair of ruby slippers. Yep. Those slippers made us feel like a movie star and suddenly we realized how important clothing really is to our sense of who we are. While many of us left the ruby slippers behind in childhood, we found other styles and colors that made us feel equally pretty. While some may watch trends and tweak their wardrobe seasonally as "in" colors and styles replace "out" colors and styles, many of us are unprepared to cull ruthlessly. We hold on to our outfits because they make us feel attractive or confident or successful. Our choices of clothing and their colors can disclose a lot about our dominant color preferences and how we relate to color on a one-to-one basis. Take a look in your closet and you will probably find trends and themes. What is the dominant color in your closet? What are your "accent" colors? When are you most likely to wear certain outfits? Your closet can provide you with insights into both your color preferences and prejudices. Keep those in mind when selecting colors with which to scrapbook, and you'll find yourself creating pages that strike just the right emotional note within you.

Finding Inspiration for Your Art

Inspiration is all around us, and clever scrapbookers draw ideas for color palettes from many sources. Whether indoor or outdoor, on the go or nestled at home, keep your eyes open for palettes that will bring life to your artwork.

Color chips found at most home-repair and paint stores not only introduce a wide range of hues but are often collected into palettes of colors that work well together for decorating concepts.

Mother Nature provides an array of potential scrapbooking palettes from the vibrant colors of a flower garden to the muted shades of a mossy glen and the stark colors that make up a Southwestern desert.

Fabric stores harbor racks of material that feature well-conceived color palettes for all seasons. Whether it is a gentle calico or a burning swatch of satin, there is a plethora of color schemes to choose from.

Makeup palettes, which change seasonally, introduce a selection of colors which work well together. From base to blush, and lipsticks to eye shadows and nail polishes, these colors can work together on scrapbook pages.

Works of art including paintings by the Masters, showcase brilliantly executed uses of color and successful color palettes. A trip to a local museum can inspire you to choose your own color combinations.

Advertisements are pieces of artwork designed to capture the eye and emotions of the viewer. Look to billboards, magazine ads, logos and other forms of marketing materials for great color palette concepts.

Homeware such as plates, mugs, linens, comforters and napkins, are designed to appeal to the eye. They can also provide great ideas for color palettes that are versatile and fun.

Interior design magazines and books are written by experts in color management for people who are seeking palettes to use when decorating their homes. Those same color combinations work well on well-designed scrapbook pages.

Book and hobby stores are filled with terrific books that offer a plethora of creative ideas. Broaden your search for inspiration by picking up books designed for a wide variety of crafters including bookmakers and cardmakers.

You know, it's funny. When we were walking through the cornstalk maze I was watching your excitement. You weren't scared or uncertain as you rounded each bend. You were eager to explore the path in front of you and were intrigued by the mystery. Even the dead-ends made you laugh. You were ready to face the unknown, and thinking about that made me happy. In many ways, life is like this corn stalk maze. It's a journey filled with so many twists and turns with the end result being what you make it! Enjoy all the turns... Even the dead-ends!

OCT 2004

Life's Journey

Marla Kress

INSPIRATION CAN REQUIRE EFFORT

Often we feel that our artwork is stuck in a rut. If your artwork has started to look uninspired, break out of the rut by following these simple tips.

- Evaluate. Lay out all your pages on the living room floor. Do you see any patterns? Do you see reoccurring colors? Make a note of the repeated elements, and the next time you make a scrapbook page, do everything you can to AVOID those patterns and colors.

- Take a different look. Hold your scrapbook page up to a mirror. The image will appear backward. This often reveals "design flaws," including unsuccessful color combinations, that can be easily corrected.

- Search out a new technique. Working with different materials sometimes forces us to work in new and inspired ways.

- Copy a Master. This age-old technique gets you "inside the creative mind" of an artist you admire. It forces you to do things differently, to expand your creative vision.

- Play. Don't be afraid! Have fun making your page. Yes, you may waste some supplies, and, yes, you will make some pages that are so-so. But that is part of the learning and growing process.

Favorite Palettes Through the Decades

Color popularity, like fashion, changes. A palette that was all the rage at the turn of the century shifts into a very different color combination ten years later. Favored palettes often relate to events taking place at that moment in history and speak to the social climate of the times. Use historical palettes to capture the essence of specific times in history, or draw upon them to inspire layouts using your more recent photos.

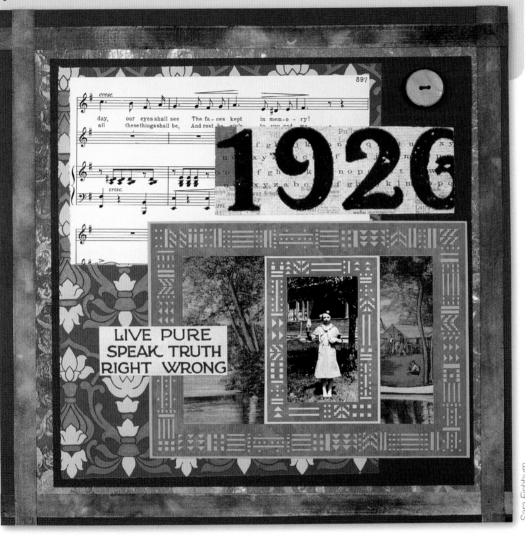

Sara Fishburn

Back in the 1920s

The Great War is finally over.

Slang is the fashion, with words like: broad, bunny, canary, dame, doll, and the cat's meow used to describe women.

The U.S. population tops 106 million, and the life expectancy is 53.6 years (men), 54.6 years (women).

Car travel from California to New York takes 13 days.

Architecture is all about building "up," and the Woolworth Building, Empire State Building, (NYC) and Wrigley Building (Chicago) prove it.

Silent screen stars include Rudolph Valentino and Clara Bow. The first talking picture, *Don Juan*, premieres in 1926.

On Broadway, Gershwin is the main man. Shows like An *American in Paris, Show Boat* and *Funny Face* are hits.

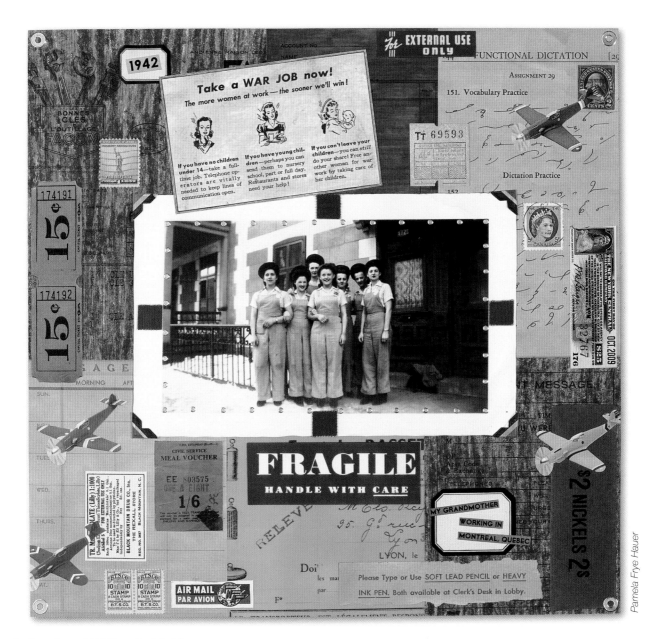

Pamela Frye Hauer

Back in the 1930s & 1940s

1930s: The Depression is on, and the average American's salary is $1,368, while unemployment rises to 25%.

President Franklin Roosevelt interacts with the public through his famous fireside chats.

Mystery novels by Agatha Christie, Dashielle Hammet and Raymond Chandler are popular.

The game, Monopoly, is introduced and sells like hotcakes.

The zipper begins to replace buttons on clothing.

Big bands led by Benny Goodman, Duke Ellington and Glenn Miller are tremendously popular.

1940s: Slightly more than half of American homes have indoor plumbing.

The Supreme Court decides African Americans have the right to vote.

WWII rages, and Americans farm "Victory Gardens."

Pinup girls, including Rita Hayworth and Betty Grable, are GI dream girls.

The Slinky, frozen dinners and Tupperware become popular.

Theater hits include *The Skin of Our Teeth, Glass Menagerie, Streetcar Named Desire, Oklahoma* and *Carousel.*

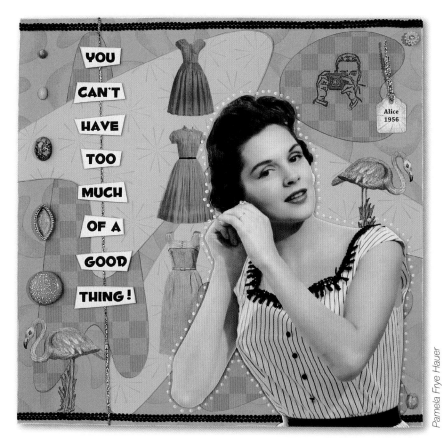

Pamela Frye Hauer

Back in the 1950s

Bread costs 14 cents a loaf.

Anticommunist feelings run rampant, and bomb shelter plans, created by the government, become commonplace.

The phrase "Under God," is added to the Pledge of Allegiance.

Rosa Parks refuses to give up her bus seat to a white man.

The polio vaccine is created and given to millions of school children.

Pony tails and poodle skirts, slicked back hair and drive-in movies are the rage.

Fluoride toothpaste and Quaker instant oatmeal make their debut, and so does Disney Land.

Back in the 1960s

The post WWII baby boom creates 70 million teenagers in the 60s.

Skateboards, Barbie, G.I. Joe, the Troll and slot cars become popular. Bouffant hair and knee-length dresses give way to short or very long hair, go-go boots, miniskirts and hot pants.

Martin Luther King, Malcolm X and the Black Panthers share their messages.

The hippie movement takes hold and the use of marijuana and LSD soars.

President John F. Kennedy is assassinated by Lee Harvey Oswald.

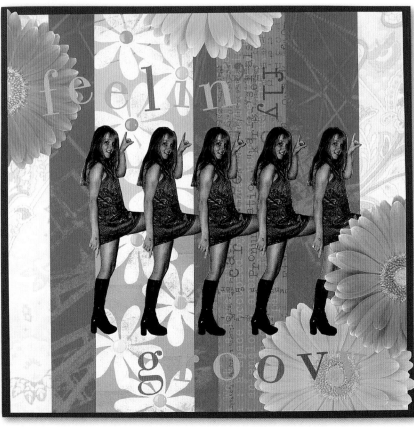

Sarah Fishburn

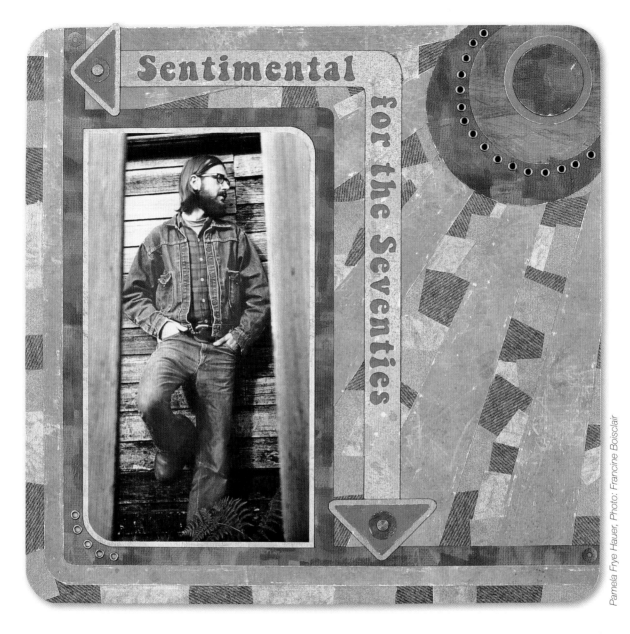

Pamela Frye Hauer, Photo: Francine Boisclair

Back in the 1970s & 1980s

1970s: The average American's annual salary is $7,564.

Four students at Kent State are gunned down by members of the Ohio National Guard.

Mood rings, lava lamps, smiley faces and pet rocks are "must haves," as are bellbottom pants, platform shoes, leisure suits and videocassette recorders (VCR).

Star Wars, the *Towering Inferno, Poseidon Adventure, The Godfather, Jaws* and *The Exorcist* meet with wide appeal.

1980s: Team sports and other after-school activities become increasingly popular for children.

New wave, punk, rap and hip hop grow in popularity.

Successful and memorable movies include *On Golden Pond, Back to the Future, Star Trek, Good Morning Vietnam* and *Driving Miss Daisy*.

Sandra Day O'Connor becomes the first woman Supreme Court justice.

The Vietnam Veterans Memorial is dedicated.

How Cool is That?
working with chilly blue and green

The remote bottom of an icy pond

Moon shadow blanketing winter snow

Spanish moss on a reaching branch

Umbrellaed hideouts beneath a
willow's tears

Brrrr

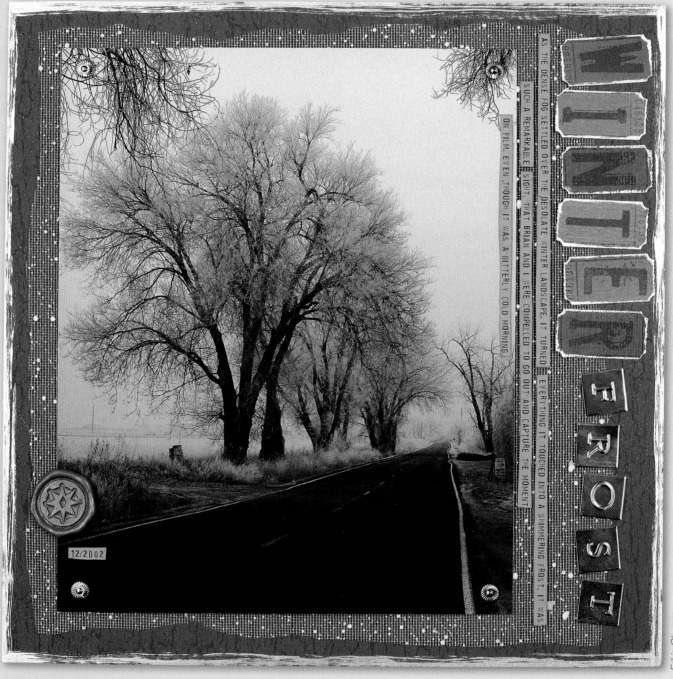

WINTER FROST

AS THE DENSE FOG SETTLED OVER THE DESOLATE WINTER LANDSCAPE, IT TURNED EVERYTHING IT TOUCHED INTO A SHIMMERING FROST. IT WAS SUCH A REMARKABLE SIGHT, THAT BRIAN AND I WERE COMPELLED TO GO OUT AND CAPTURE THE MOMENT ON FILM, EVEN THOUGH IT WAS A BITTERLY COLD MORNING.

12/2002

Erikia Ghumm

31

Dip into Chilly Blue and Green

Brrrrr. Blues and greens are the coolest colors in your scrapbooking palette. These tried and true favorites, with all their variations, are perfect for scrapbooking everything from frosty winter landscapes to cool summer escapes. They can be remote and as airy as a breathy whisper, or bellow their intention. The psychological and physiological effects of cool colors are well documented. Studies show that, when closed in a blue room, subjects feel much colder than when closed in a room painted red-orange. And race horses put in blue stalls cool and calm down faster than horses placed in red-orange stalls. Understanding the impact of cool colors allows you to select complementary shades that charge or further chill down your layouts and insure stunning successes over and over again.

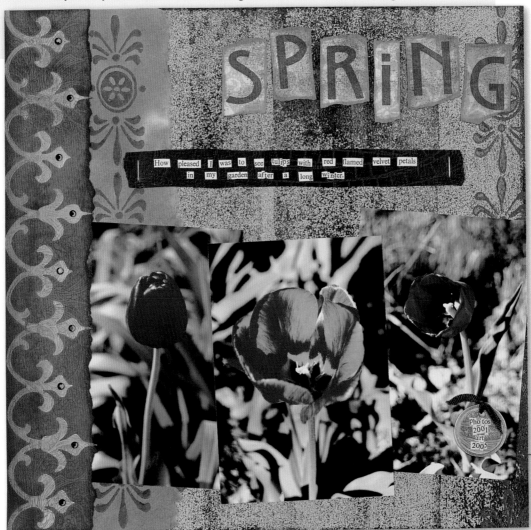

How pleased I was to see tulips with red flamed velvet petals in my garden after a long winter.

Erikia Ghumm

Spring

Fresh green painted and stamped paper provides a lush background for vibrant floral photos on this page. Other elements, including the decorative peach sticker and jewel-adorned border, stamped and painted title, journaling block and tag, draw their colors from the flowers. Journaling, cut from old books, provides a poetic message.

STROKE OF GENIUS While a border sticker on brilliant blood orange paper provides a vibrant contrast to grassy green background paper, the tiny green rhinestones add both dimension and dewdrop glitter, contributing enormously to the appeal of the page.

Peek A Boo

A wide range of blues is featured on this great page with creative borders made from fabric, ribbons, fibers, buckles and cardstock. The stamped fabric repeats the message carried by the journaled tag.

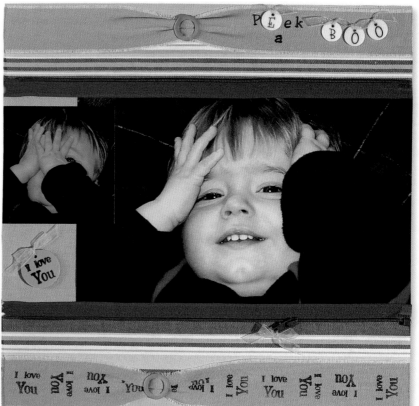

Cindy Smith

Bowl Ero

A vibrant shade of teal dominates this sporty layout. Borders made of printed and stamped flame-colored paper support the stamped flame images at the bottom of the page and add excitement to the palette. Letter stickers form the title above a journaled caption. A personalized bottle cap, heart nailheads and staples score.

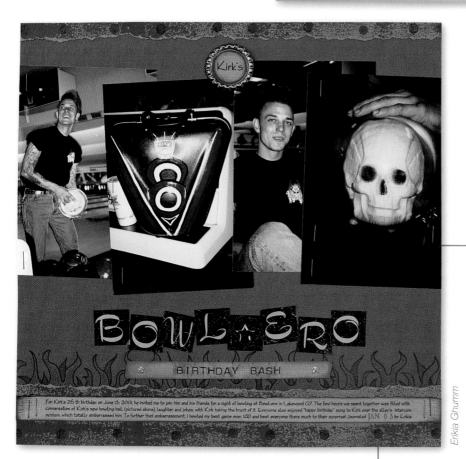

Erikia Ghumm

 AH-HA! Think "bowling alley" and you envision a windowless building filled with high-powered, competitive energy. The deep, heavily saturated shades in this palette capture that unique atmosphere perfectly.

Balance Cool Blue Pages

Just as snowy winter days call for a cup of warm cocoa, blue pages may cry out for a bit of warming up in order to fit your theme or artistic concept. Take the chill out of primarily blue pages with complementary colors such as rich earth tones, mellow pinks or vibrant and bold reds and golds.

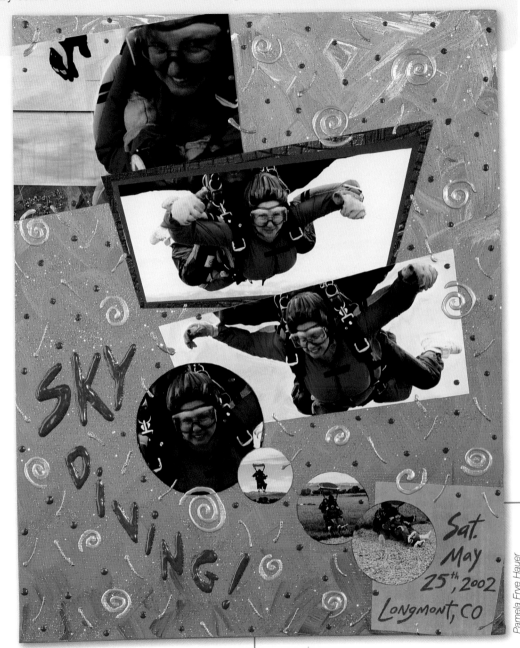

Pamela Frye Hauer

Sky Diving

A blue canvas background painted with acrylics and sprinkled with glitter is heated by lettering and page accents created with dimensional paint. The red patterned paper photo mat and orange journaling block further energize the page.

STROKE OF GENIUS Create a page with momentum by cropping photos into a variety of shapes and sizes. Mount them on a page so the sequence of events (top left corner to lower right) emulates the sense of falling documented in the sky-diving experience.

Attitude

A blue photo mat and pale green cardstock background are warmed by a patterned title border, which draws in yellow and red hues. Brown inking, red patterned ribbons, red journaling strips and a heavily inked creamy colored journaling block further infuse this page with a sense of warmth.

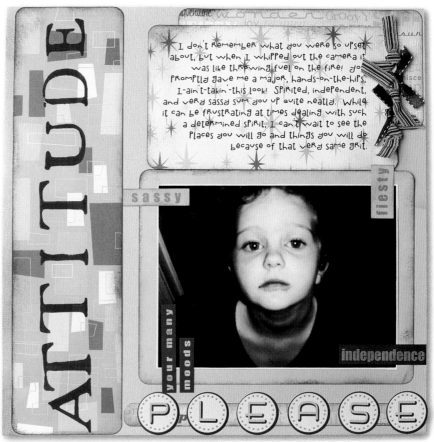

Amy Brown

That Denim Dress!

A rustic blue denim page is warmed and softened with floral and pink papers sitting on a background made from an enlarged photo of denim material. The photo mat, created in the same manner, is ripped, wrapped in a delicate tagged embellished ribbon, and mounted. Additional journaling, a flower, beads, metal letters and a pale pink safety pin add a touch of feminine fun.

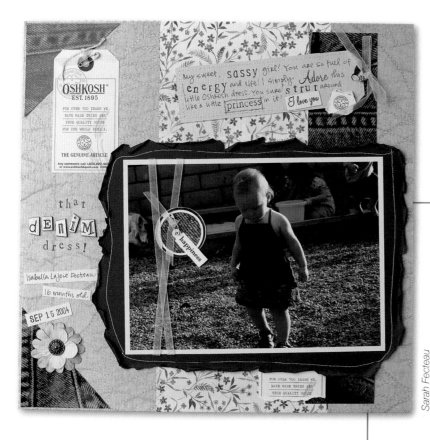

Sarah Fecteau

STROKE OF GENIUS The clothing tag displayed on this page offers a whimsical and decorative element that supports the page theme while providing a touch of memorabilia for future generations to enjoy.

Turn Up Blue's Chill Factor

Even chilly blue can become colder when iced down in just the right way. Reach for shades of blue that contain less yellow and more gray when scrapbook pages call for very cool colors. Combine your coolest blues with cool purples and whites and embellish with metallics to keep the thermometer turned way down.

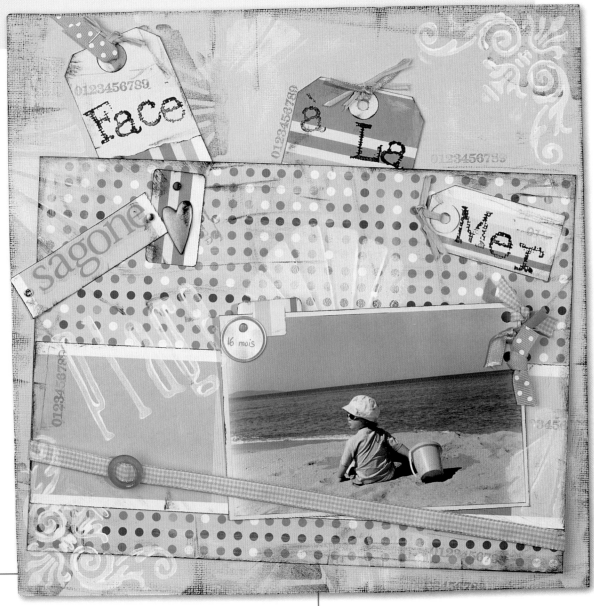

STROKE OF GENIUS This cool page defines the word "irony." Here, a warm weather beach scene is scrapbooked in the iciest blues imaginable. The blues are so cold they appear sun-bleached, which makes the page work.

Look, the Sea

A stamped and inked textured cardstock background layered with stamped and inked patterned paper, tags and a matted photo come together on this distressed page. Ribbons, charms, buckles and brads in cool tones contribute to the beachside scene.

Spring

A large piece of printed transparency is sewn and stapled onto icy blue cardstock to form the basis for this cool spring layout. The purple flowers in the photo add a strong shot of another cool hue. The title, made of letter stickers, is sanded for a more relaxed feeling, while the white paper bookplate was inked blue to work with the predominant colors of the layout.

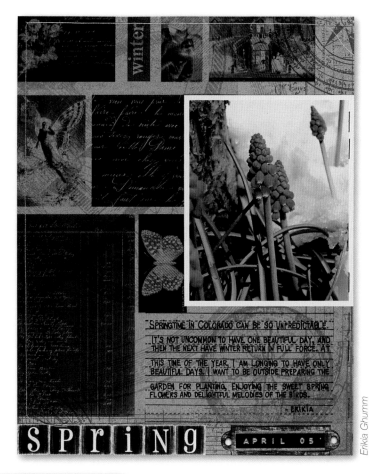

Erika Ghumm

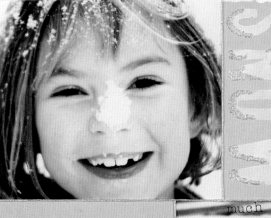

annie

People in the rest of Canada who get lots of snow must think we are crazy here on the west coast because we get all excited when we get just a few inches. The news warns people not to go out unless they have to, schools are closed and people call into work saying they can't come in. See, we are crazy as life still has to go on. But the one group of people who are happy about it are the kids who think of a day off school filled with nothing but exploring a winter wonderland. January 3rd, 2004

Trudy Sigurdson, Photos: Sandra Ash

Snow Much Fun

Black-and-white photos mounted on blue cardstock define the palette for this wintery page. A white stamped title outlined in crystal micro beads cools things down even further and the corresponding ribbon surrounding the photos adds its own chilly quality. Journaling on decorative strips of snowy white cardstock, brads and a silver tree embellishment support the theme.

AH-HA! White paint applied randomly around a pale blue cardstock background supports the illusion that the entire page has been set in a snowbank, turning down the thermostat even more.

Accent Blue Pages with Charged Colors

A blazing yellow sun heats up a backyard pool just as a flaring yellow embellishment can heat up a blue scrapbook page. Vibrant shades of orange, red and other steamy colors make perfect page accents on blue palette pages that call for some pop and sizzle.

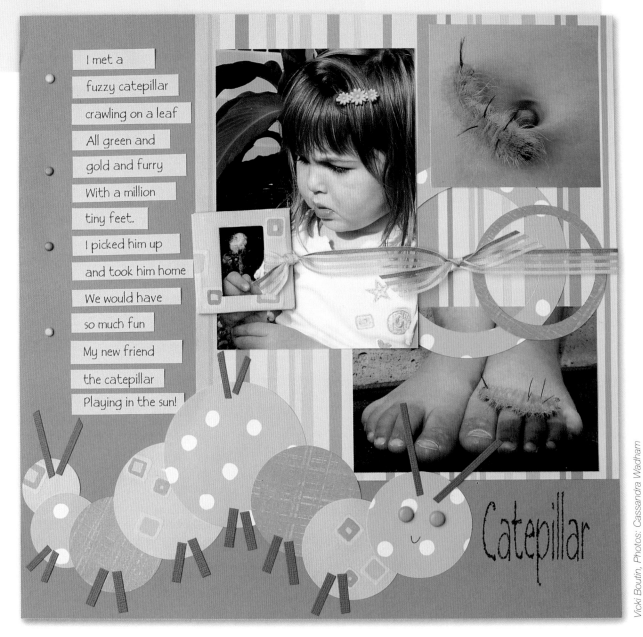

I met a

fuzzy catepillar

crawling on a leaf

All green and

gold and furry

With a million

tiny feet.

I picked him up

and took him home

We would have

so much fun

My new friend

the catepillar

Playing in the sun!

Catepillar

Vicki Boutin, Photos: Cassandra Wadham

Caterpillar

A vivid blue cardstock background is charged with neon paper accents on this fun and fuzzy page. Photos are matted on a single patterned paper block. Punched circles of patterned papers form the caterpillar's body, while purple cardstock strips form legs, and brads stand in as eyes. A ribbon-tied slide mount covered in coordinating patterned paper, colorful brads and creative journaling complete the page.

AH-HA! A compelling page title is yours for the making by simply identifying the strongest color within your photo. Type the title words utilizing that color. Print out the title and, with a craft knife, cut away the center of the letters.

Come and Get It

A frisky photo finds a home on cool blue textured cardstock on a layout that is heated with hot pink elements. Hand-painted leather floral embellishments, a painted picture frame, multi-colored ribbons, journaling and a dynamic title draw their colors from the dog's play toy.

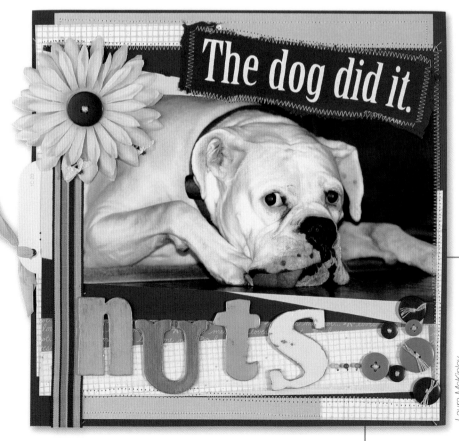

The Dog Did It

A stitched blue cardstock background, blue fabric title block and blue buttons are energized with bright yellow elements on this how-cute-is-that page. Yellow papers, a bee-adorned flower and a journaling tag (inset below) heat things up. But nothing steals focus from the terrific photo, (although the chipboard "NUTS" gives it a heroic try!)

STROKE OF GENIUS
Printed fabric can make a simple and powerful page title. Stitch it or secure it with brads for a quick and easy title treatment.

39

Take Time for Teal and Turquoise

Splash blue with yellow. Stir well and you create tasteful teal and turquoise. Combined with hot colors such as red and coral, these shades can be alluring as a Southwestern necklace. Snuggled next to earth tones they become rich as a hand-thrown clay pot.

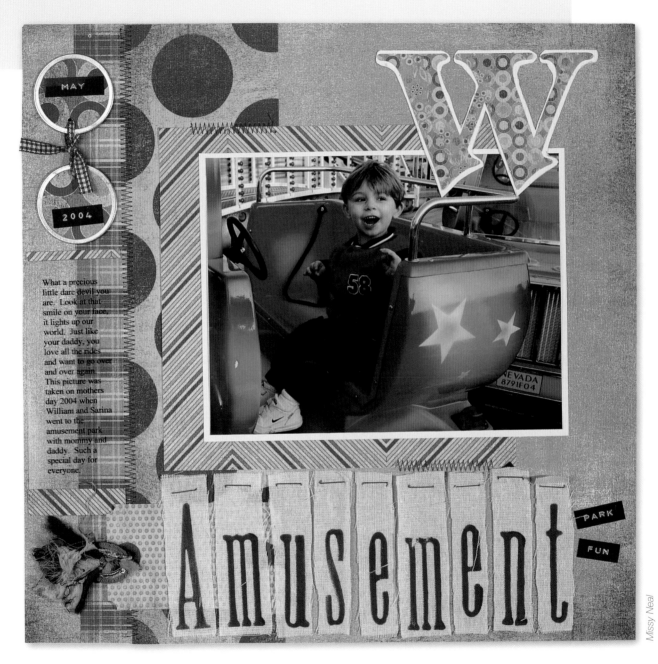

What a precious little dare devil you are. Look at that smile on your face, it lights up our world. Just like your daddy, you love all the rides and want to go over and over again. This picture was taken on mothers day 2004 when William and Sarina went to the amusement park with mommy and daddy. Such a special day for everyone.

Missy Neal

Amusement Park

Turquoise meets a palette of primaries—red, yellow and blue—in a swirl of vibrant color on this energetic page. Patterned papers, fibers, coordinating patterned paper tags and a bold stapled title treatment convey the model's fun. Journaling tells the rest of the story.

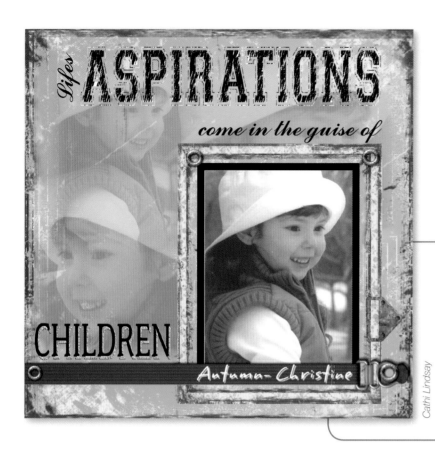

Cathi Lindsay

Life's Aspirations

Turquoise takes on the flavor of earth tones on this rich digitally created page. Brown "chalked" paper edges, a dappled photo frame, black title and white journaling provide contrast to the sweeping blue background, as do the ribbon border and faux buckle.

AH-HA! Create intricate looking background paper digitally by flipping and merging cropped variations of the focal photo.

Who Says Boys Don't Like...

A background of shocking turquoise is accented with cool pink accents, a pink envelope and patterned papers that include pinks as well as cool blues and greens. Compelling photos, an icy green letter "P" tied with a frothy pink ribbon and creative stitching make this blue boy page appealing to all genders.

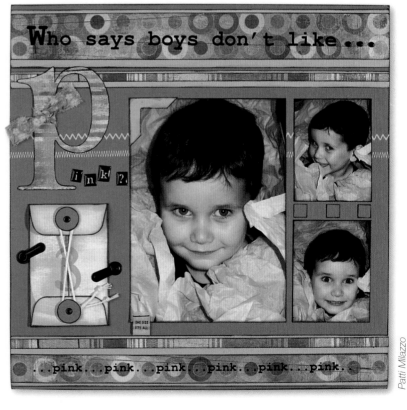

Patti Milazzo

Turquoise Superstitions

While the color blue has long been believed by some cultures to ward off evil, teal and turquoise are viewed as especially powerful. In some Latin American countries houses have painted turquoise doors and window ledges—believed to prevent bad spirits from crossing over thresholds and into homes. Native Americans use turquoise stones on belts, jewelry and weapons as protective talismans.

Work with Gentled-Down Blues

Like a cloudy summer sky, pastels and light blues evoke a sense of relaxation and peace. Mixed with other cool colors, they can be wispy and barely-there. But, with a careful hand, you can couple them with heavier or hotter colors and expect them to hold their own.

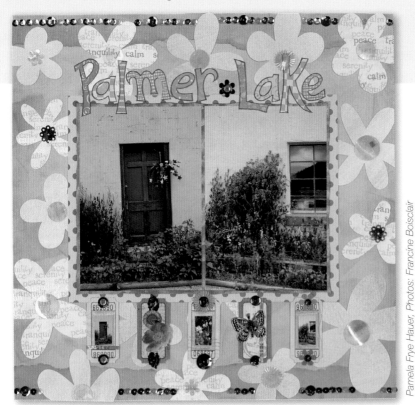

Pamela Frye Hauer, Photos: Francine Boisclair

Palmer Lake

A stunning pastel blue background is created with flowers hand-cut from different shades of pale patterned paper, mounted on blue cardstock. Strips of torn blue paper form page borders, brought to life with rows of sequins. A hot pink metallic photo mat, pink patterned paper title treatment and bright collages mounted upon stickers, add energy, to prevent the page from becoming too sleepy to be interesting.

Treasure

Hushed and contained, this layout flirts with a palette of cool blues and steel grays. A quiet title composed of letter stickers, a flowing wire word and a faux wax seal complete the page in a way that carries out its gentle nature.

AH-HA! Add visual interest to colored cardstock by lightly inking it. Add a stamped pattern and detail with pencil for a truly unique page.

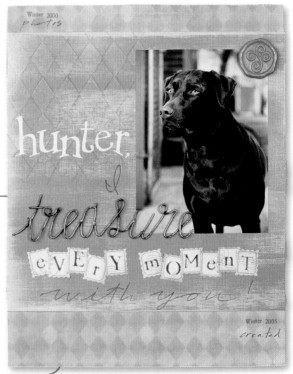

Erika Ghumm

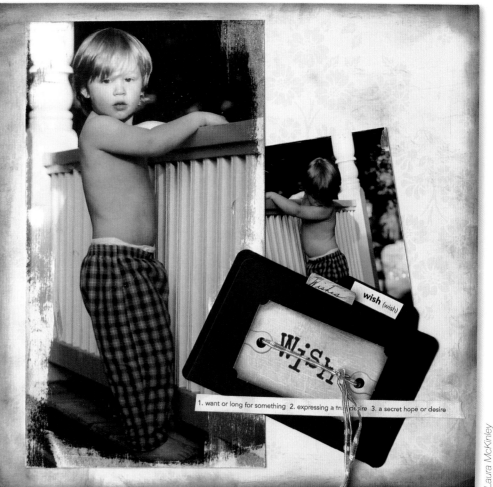

Laura McKinley

Wish

Delicate blue floral patterned paper, vibrant blue pajama bottoms, a gray-blue porch railing and title block cool down this shady page. The model's warm skin tones and colorized page elements, including the red chalked page border, cozy up the scene. The black file folder, decorated with rub-on title, definition sticker and ribbon, adds a solid element to the layout and visually balances the darkness behind the model's head in the top left page corner.

Blue Through the Ages

Blue linen was found in the caves in which the Dead Sea Scrolls were discovered.

Blue was the color of King Tut's lapis lazuli jewelry, and it was associated with immortality by the Chinese.

The Druids thought of blue as the color of harmony and wisdom.

Christians associated blue with Christ, as it was used repeatedly in early religious mosaics.

Blue was extremely popular in the 12th century, because it was viewed as unthreatening, being disassociated from either royalty or clergy.

Blue, and Another Primary, Go a Long Way

Anyone who has groaned under the weight of that second or third piece of Thanksgiving pumpkin pie knows there really can be too much of a good thing. The lesson also applies to primary colors which, when served with an overly generous hand onto blue pages, overwhelm the photos. Often, in art, a dollop of primary color accomplishes what a spoonful won't.

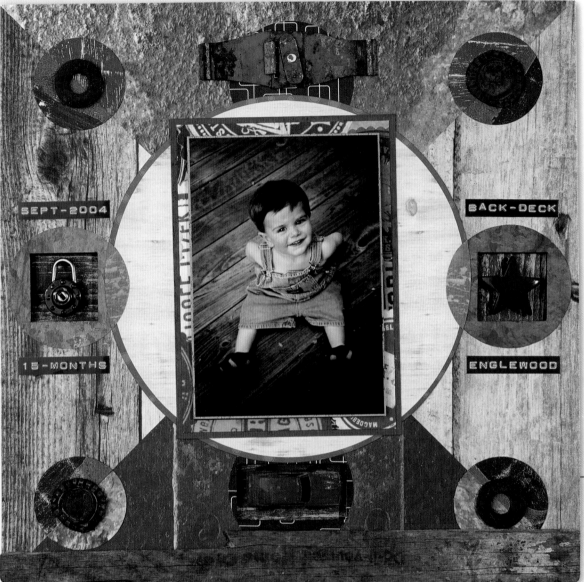

SEPT-2004

15-MONTHS

BACK-DECK

ENGLEWOOD

Milo

A pieced background of faux wood paper creates the perfect rustic setting for this "sitting on the backyard deck" photo. Distressed embellishments, journaling labels and a printed photo mat in primary colors play off the child's blue outfit and suggest that fun is in the air.

STROKE OF GENIUS "Found objects," such as rusty washers, bottle tops, a hinge and old toy car reflect the rustic feel of the deck seen in the photo. Like weathered wood and faded denim, they somehow speak to the beauty of simpler times gone by.

Bonaire

The stucco salmon wall that fills much of the photo dictates the palette for this vacation page, which is built upon a background of faded earth tone travel- theme paper. The photo mat and journaling strips are inked in sunset colors, and the page is embraced by a ruby red frame that mirrors the same red shade found in the supporting photo.

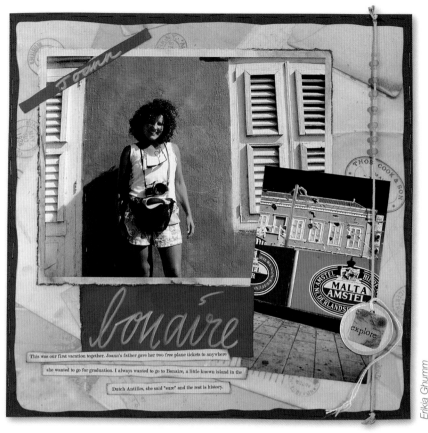

Erikia Ghumm

Dive

While the majority of watery scrapbook pages are built around a palette of blues, this under-the-sea page glows with a mellow yellow background and stamped gold title. The predominantly blue images rest on a color blocked foundation of shell-printed transparency, blue mesh and white handmade and stippled papers.

THESE PHOTOS WERE TAKEN ON A DIVE TRIP TO THE BAHAMAS. I WENT WITH MY FRIEND STEVE, PICTURED BELOW HOLDING A CLEANER SHRIMP.

THE DIVES WERE ALL CHARACTERIZED BY BIG BLUE EXPANSES OF DEEP BLUE WATER. IT WAS A BOYS ONLY KIND OF GETAWAY. TWO DIVES EVERY DAY AND THE CASINO UNTIL LATE AT NIGHT.

Erikia Ghumm

PRIMARY POP QUIZ

Class! Take out a sheet of lined paper and your No. 2 pencil. It is time for a test. (You may grade yourself by turning to page 143. Now remember, you are all on the honor system!)

1. Why do they say that a thief was caught "red handed?"

2. Where does "paint the town red" come from?

3. Why are cowards called "yellow-bellied?"

4. Why do they say "he talked a blue streak?" Where does the term come from?

5. If something happens "once in a blue moon" how often would it come about?

6. Why are some people referred to as "blue-blooded?"

Answers to the quiz on page 143

Explore the Coolest Green Ever...Moss

Green, the child of blue and yellow, is the color of sunlight reflecting off a blue sea. Depending upon the shade, green can be tranquil or acidic and downright shocking. Moss green, a shade that leans heavily toward yellow and gray, may be the most relaxing green of all. It tends to be neutral, lending itself to many scrapbooking themes and working well with an assortment of complementary colors.

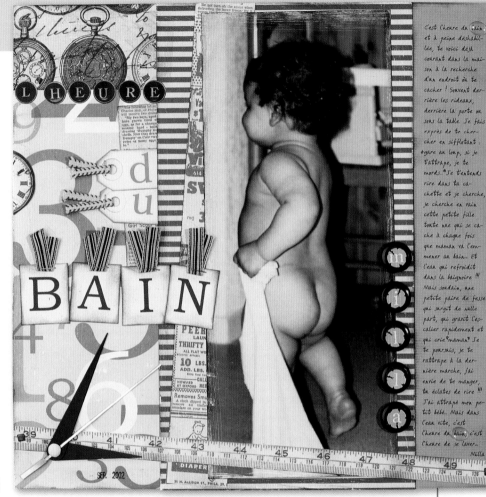

Prisca Jockovic

Time for Bath

Layered patterned papers in mossy and beige shades form the basis for this largely monochromatic page. Ribbon-adorned tags, letter stickers, a strip of measuring tape and other elements add visual interest to the page and balance the horizontal photo and borders.

STROKE OF GENIUS

The mechanism from a real clock decorates the lower left corner of the page, carrying forward the "timely" theme.

Moss

The color draws its name from a family of plants with small leafy, tufted, stems. There are many varieties and most share the same green-gray hue. The appearance of Spanish moss, which hangs in trailing streamers from trees in tropical climates, is explained in an old folk story involving two lovers—a Spanish soldier and an Indian princess. In order to keep the two apart, the princess's father tied the Spaniard high up in the limbs of a tree and refused to release him until the Spaniard would agree to leave the princess alone. This he refused to do. Over time his beard grew and grew, continuing even after his death. The beard of the Spaniard is the Spanish moss we see today.

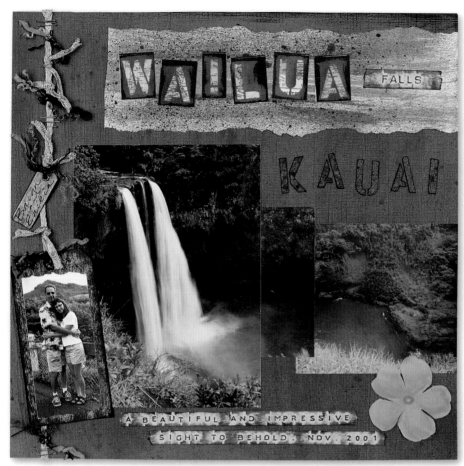

Wailua Falls Kauai

Textured mossy background paper layered with hand-painted papers with stippled earth tones, warm up this tropical page. A photo matted on a faux wooden tag, tied with decorative fibers, and a tropical flower add a shot of sunny yellow to the otherwise shady palette. The title, created in part with map letter stickers, and the creative journaling support a mood of comfortable, laid-back travel.

Erika Ghumm

STROKE OF GENIUS

No title or journaling is needed on a page that tells the story through the use of clever embellishment blocks. The blocks actually provide necessary information about the model. Each block represents an aspect of his personality and the way he is perceived by the artist.

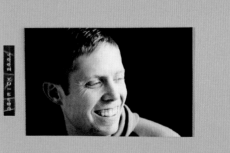

Husband, Son, Brother, Friend

Moss green and black cardstocks are responsible for the success of this clean, cool spread. The almost stark mossy background provides a pristine platform for a black-and-white photo. Small handmade embellishment blocks add a thimble-full of complementary colors, while keeping this page masculine and visually interesting.

Mary MacAskill

Play with Greens that Just Won't Hush

Lime green derives its "pop power" from a heavy dose of lemon yellow. Anything with a squeeze of lime is guaranteed to have a bite, and these pages are no exception. Heat up lime's pucker-power with hot colors or back it off with soothing blues and purples. Either way, you're sure to have a page that screams, "Party time!"

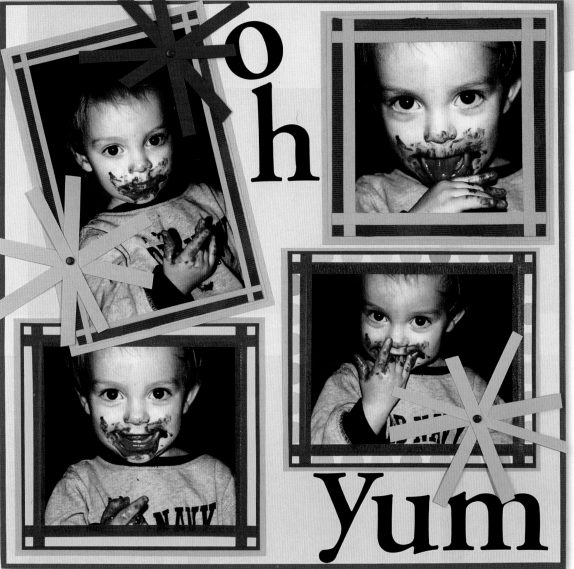

Sara Fishburn, Photos: Corina Gerety

Oh Yum

This page, created with red and yellow cardstocks, complemented by lime accents, proves that a little lime goes a long, long way. Photos, triple matted and wrapped in paper ribbons, draw the eye. Paper pinwheels, secured by tiny red brads, and a bold black title add to the page without stealing attention from the photos.

Ahoy, Limeys!

The lime fruit, grown on trees in tropical climates, played an important role in history. Centuries ago, English sailors frequently became ill with an affliction known as, scurvy, which caused bleeding of the gums and under the skin. Eventually, it was discovered that sailors who received a lime a day, increasing their intake of vitamin C, no longer suffered from the unpleasant disorder. As such, British sailors became known as, limeys.

Girlfriends

A pale, striped patterned paper background offers a platform for layers of vibrant green cardstock and complementary floral patterned vellum strips. An intense purple cardstock mat, paper ribbon strips, a heart die cut and a sentimental quote on a metal plaque add their own shots of vibrant color and dimension.

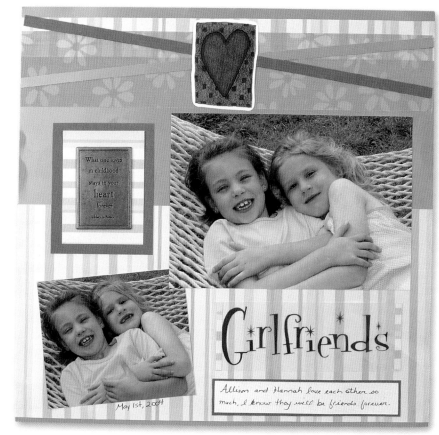

What one loves
in childhood
stays in your
heart
forever

Girlfriends

Allison and Hannah love each other so much, I know they will be friends forever.

May 1st, 2004

Lisa Dale

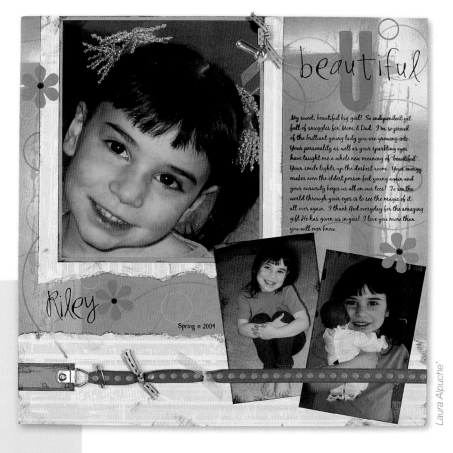

beautiful U

My sweet, beautiful big girl! So independent yet full of snuggles for Mom & Dad. I'm so proud of the brilliant young lady you are growing into. Your personality as well as your sparkling eyes have taught me a whole new meaning of "beautiful." Your smile lights up the darkest room. Your energy makes even the oldest person feel young again and your curiosity keeps us all on our toes! To see the world through your eyes is to see the magic of it all over again. I thank God everyday for the amazing gift He has given us in you! I love you more than you will ever know.

Riley

Spring • 2004

Laura Alpuche'

Beautiful

A brilliant lime green patterned paper background and gentle ripped patterned paper photo mat and border provide the balance of energy for this page. The vibrant yellowish green is cooled down a touch with stamped blue flowers and a stamped "U." A blue ribbon and a solid journaling block printed on a transparency round off the page.

Tame Acidic Green Pages

Acid greens are fun to work with, but anything with that much burn has to be handled with care. Take a bit of the acid out of these greens by combining them with cool blues and warm earth tones for cozy yet vibrantly exciting pages. Used sparingly and tempered with the right complementary colors, acidic green can be potent and still safe for scrapbook art.

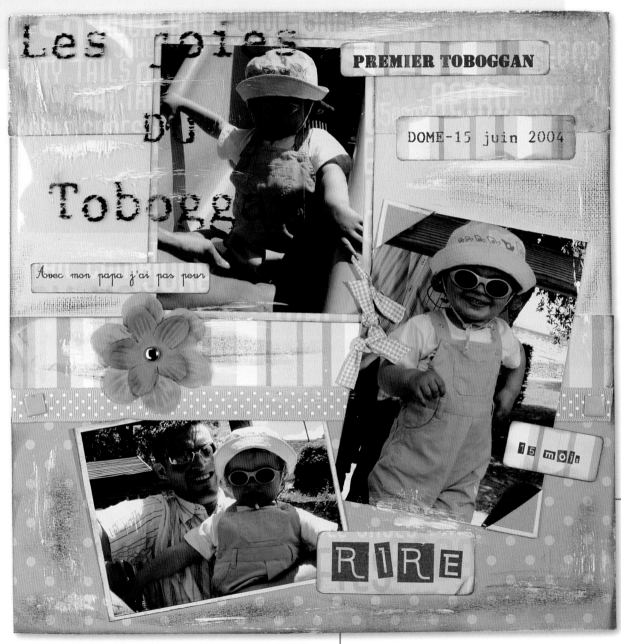

Karine Cazenave-Tapie

Toboggan's Pleasures

Inked and distressed strips of patterned paper form the basis for this "let's play" page. Patterned paper journaling blocks and a transparency title supply information about the day's activities, while ribbons, a silk flower and decorative brads complete the scene.

 AH-HA! Reduce the intensity of acidic green by sanding the paper. Lightly chalk or ink the distressed paper to further mute the lime shade.

Special Delivery

Lime green patterned paper laid alongside other papers with warm earth tone palettes, a woven ribbon and a bold black-and-white harlequin print make this layout visually arresting. A bold black "M" for Maxence atop a creamy title block, ribbons and a journaled transparency add their own dynamics to the page.

AH-HA! Break up the body of acidic green with warm and dramatically bold patterns that both balance the layout and help draw the eye away from the hottest green elements. Below, a large neutral title block ("M") further diminishes the expanse of visible green, making the page easier on the eyes.

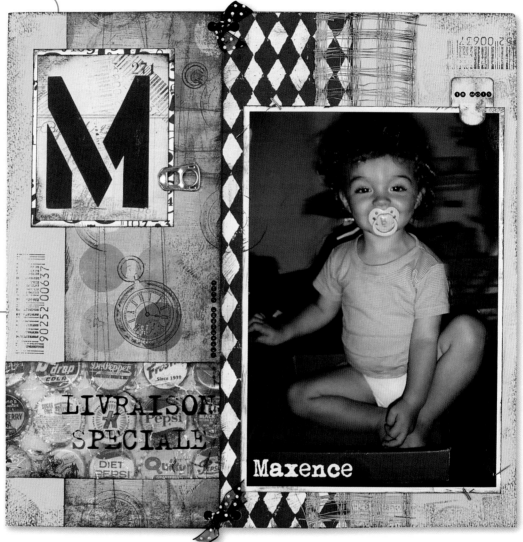

Karine Cazenave-Tapie

Green Through the Ages

Green is a sacred color to Muslims, and those who have visited Mecca wear green turbans.

Ancient Romans considered green a restful color, and the Japanese view the color green as being linked to eternal life.

In the Middle Ages, green gemstones were believed to protect a maiden's chastity, so young unmarried women often wore necklaces and other trinkets made of emeralds and jade. Jade was also used in the Orient in love potions.

Green limes were used to irritate and redden the lips of ladies of the French court, making them appear more seductive.

Relax with Grassy Green Shades

Grass green is the color of Christmas holly and also the color of a Saint Patrick's Day shamrock. And that is exactly what makes working with this shade a challenge. Few photos can hold their own when plopped down in a field of intense grass green without looking a bit like greeting cards. So mix grassy green with unconventional complementary colors and use grassy greens sparingly for best results.

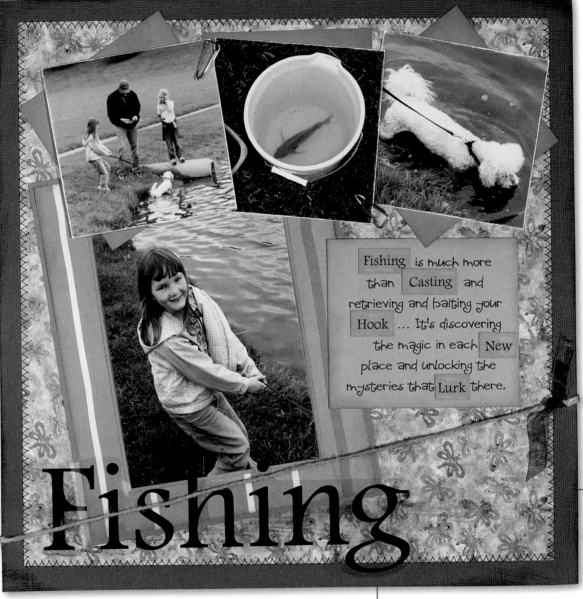

Fishing is much more than Casting and retrieving and baiting your Hook ... It's discovering the magic in each New place and unlocking the mysteries that Lurk there.

Fishing

Inked green patterned paper sewn over textured grass-green cardstock helps set this cool-as-pond-water scene. Orange patterned paper and cardstock, photo mats and orange highlighted text within the journaling block provide a stroke of earthy orange. A secret journaling block hides under the flip-up photo in the upper left corner of the layout. Stickers, ribbon, jute and triangle clips embellish the page.

 AH-HA! Stitching patterned paper onto olive cardstock not only frames the page but also gives it a "country-style" homemade feeling.

Soccer

A sheet of patterned paper mounted on black cardstock creates the field for this distressed photo and creative lettering. Cardstock and patterned title letters in shades of green, pink and black are distressed and inked before iron-on letters are applied. Embossed silver stencil letters are strung on decorative ribbon across the bottom of the page. Painted hinges, swirls and other embellishments complete the sporty layout.

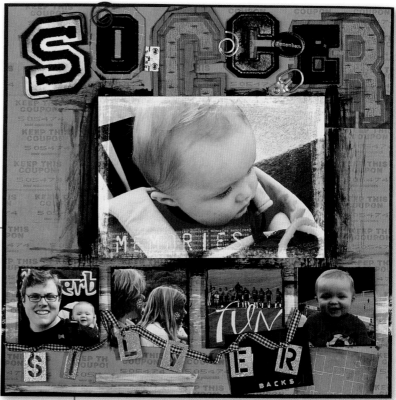

Danielle Thompson

AH-HA! Create a "frame" for a photo by making rough brush strokes across background paper with dark acrylic paint. Repeat with a secondary color to add even more drama.

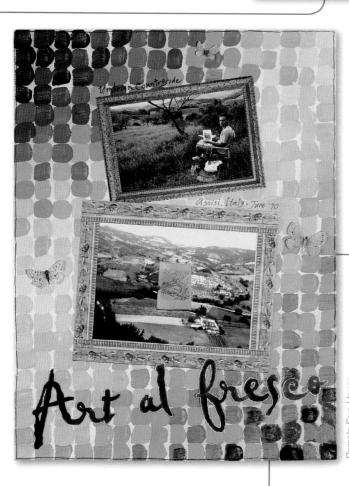

Pamela Frye Hauer

Art Al Fresco

A sheet of canvas and daubed-on acrylic paints are used to create the background for this one-of-a-kind masterpiece. Photos of an artist at work are showcased in elaborate paper frames, while a hand-cut title and tiny butterflies add a touch of embellishment.

AH-HA! The subtle movement between colors on this background is created by careful gradation of the acrylics paints. The grass green on the page's bottom slides gradually toward the purple of surrounding hills. The background palette mimics the scene in the photo.

Apply Just a Sigh of Green

Soft greens provide an atmosphere that is as compelling as a baby's heartbeat. Paired with the right complementary colors, these gentle greens can support vibrant color, or black-and-white photos. Gentle greens are relaxing to the eye and allow viewers to let down their guard and simply lean into the picture.

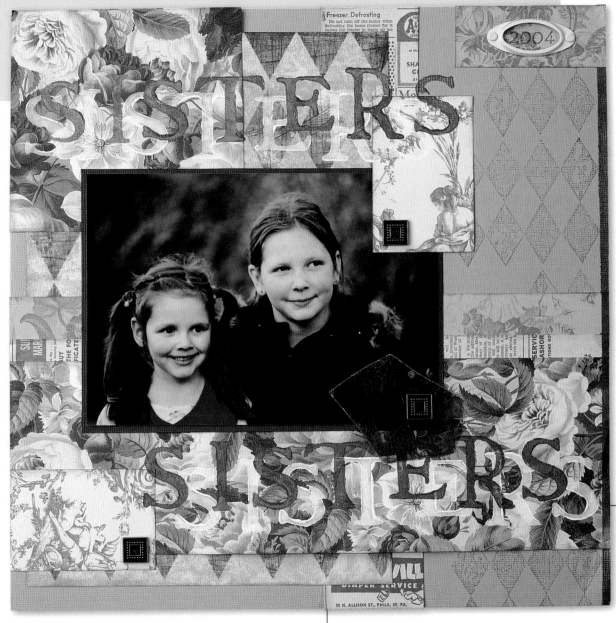

Debra Fuller

Sisters

Four lightly inked corresponding patterned papers create depth on this sweet layout. The color palette, drawn from the photo's green background and the younger model's red jumper, is a tidy balance of hot and cold. A burgundy photo mat, stamped words, a mica slab and delicate metal embellishments complete the picture.

AH-HA! The toile print block mounted across the upper right corner of the photo provides a visual bridge between the page background and the picture. It guides the viewer's eye to the photo.

Bare Feet

Overlapping blocks of inked patterned papers, a large focal photo and an assortment of journaling mediums carry this kicked-back page. The page looks to the photo to define the palette, drawing the shade of green from the grass and the ruddy red from the models' feet. A personal poem and decorative brads complete the layout.

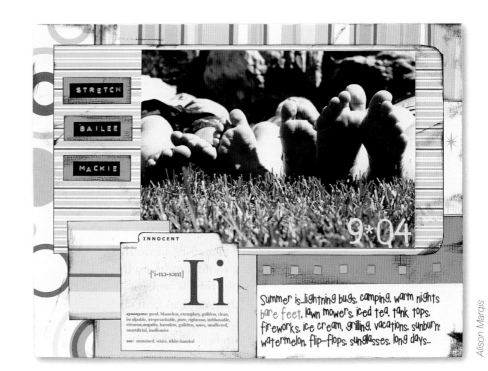

Alison Marqis

Grow

Strips and blocks of pale green patterned papers against a pure white background create a calm palette for the model's afternoon play. The airy color scheme supports, without overwhelming, the black-and-white photos. A ribbon, stickers and journaling are all in keeping with the "sweet baby at play" mood.

Wendy Inman

Notice the wide range of greens in this hay field. When scrapbooking, don't simply rely on one or two varieties of green cardstock. Explore the possibilities.

Right There in Black and White
building black and white pages

The Sunday paper, milk and
gooey chocolate cake

The 'Ouch' repercussion of a
no-nonsense confrontation

Midnight illuminated by a
determined moon

Birth and death and birth...

Dark and light

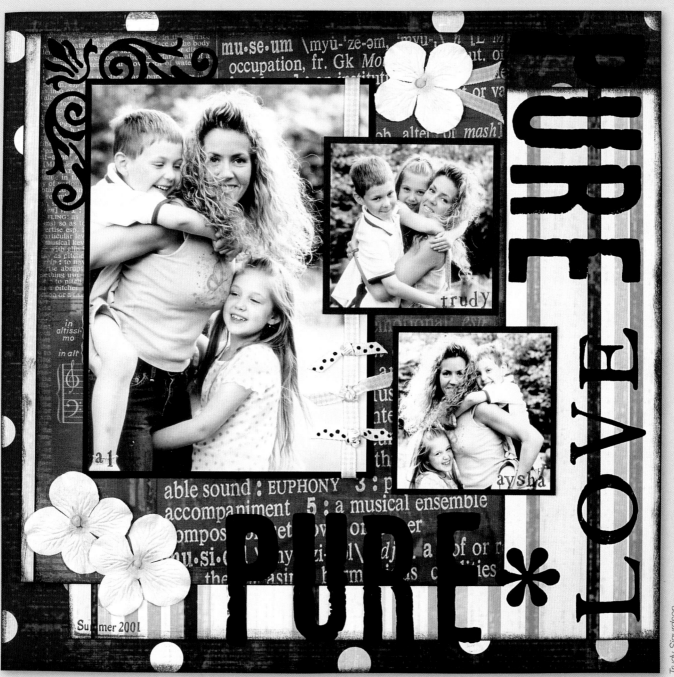

Trudy Sigurdson

Understand Shades of White

Linen, pearl, ivory, cream, beige, alabaster, dover, bone, buff—in other words, white. But the range of names describing "white" indicate how diverse the color (some would call it a "lack of color," while others argue that it is actually "all colors") really is. There are whites for bridal dresses and whites for teeth and whites for eggshells—those that aren't brown (!) and white for untouched snow. Often, it is only when the shades of white are plunked down right next to each other that their differences become obvious. Because each white has its own personality and brings a different dynamic to art, you'll want to carefully consider the shade when planning a white palette for scrapbooking.

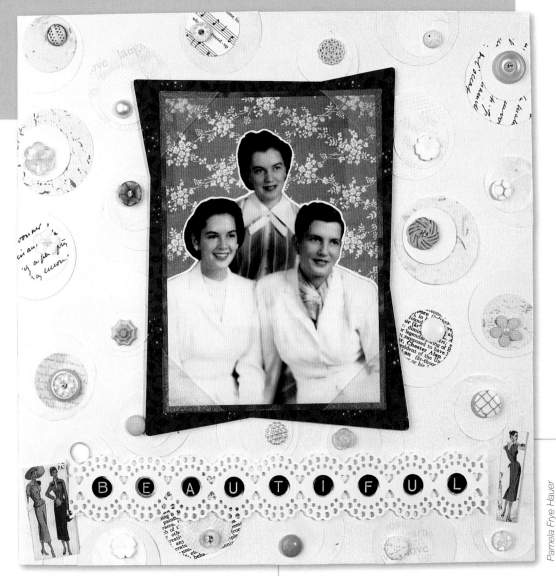

Pamela Frye Hauer

Beautiful

Punched circles of different shades of white and cream papers create this visually compelling 3-D paper background. Black, and red floral photo mats offer a contrasting platform for the silhouetted image. Fun fashion stickers support the heritage theme, while adding just enough color to keep the page from appearing faded.

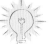

STROKE OF GENIUS Antique miniature buttons and beaded embellishments echo the sharply fashionable outfits of the three "heritage beauties" in the photo. The buttons capture that long-ago, romantic feeling of the page.

AH-HA! A white-on-white page needn't look one dimensional if the scrapbook papers vary, even slightly, in hue and texture. The greater the variety of texture in the papers, the more depth the page appears to have and the greater the visual interest.

Believe

A variety of icy white papers form the background for this powerful winter image. The picture is matted on white paper and again on a patterned mulberry. The small white tack and metal title word add even more variety, making this page as visually rich as a sundae.

Baby

Pale crackle paper, white and gold embossed paper, white pearlized paper and white cardstock support a series of kitty photos on this creamy page. Matted stencils make up the page title, while a ribbon-decorated journaling block, bookplate and sticker supply additional information. Brads, glitter and a spiral clip embellish the layout.

Julie Arsenault

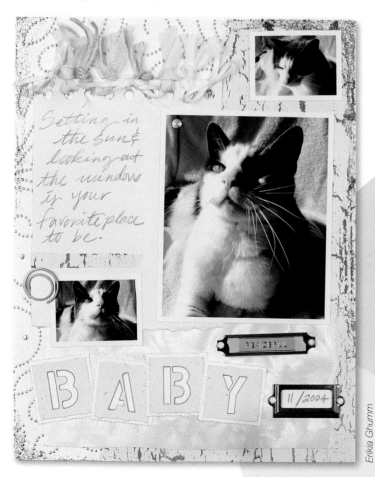

Erikia Ghumm

Anyone who has randomly picked up a quart of white paint at the hardware store, hoping to covertly cover a newly spackled spot on a white wall, knows that difference in shade matters. Oh, boy, does it matter! So spend some time with those paint chips before deciding on the right "white."

Embrace Elegant White

White can be as stark and cold as an ice storm or, combined with beads and crystals, as inviting as a beaded gown. Both virginal and sophisticated, white can be used to create bridal or baptismal pages or used for special occasions that speak to purity and simplicity. Combine white with pastels or primary colors or feature it alone on pages that are simply stunning.

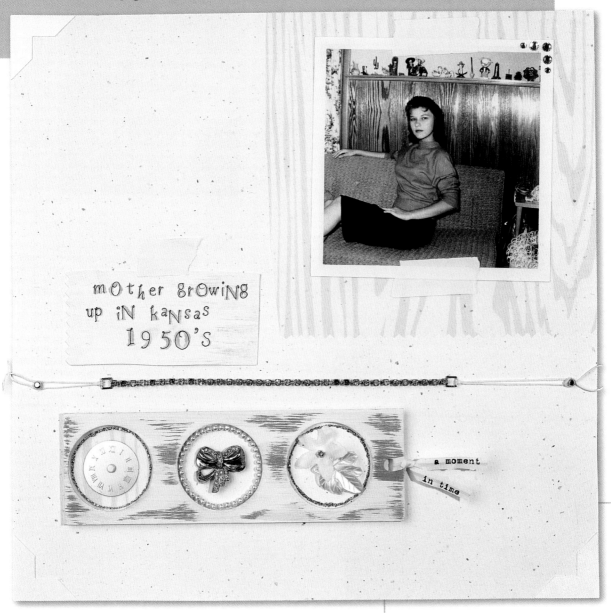

Erikia Ghumm

A Moment in Time

A creamy white speckled cardstock background is layered with faux wood vellum to off-set the heritage black-and-white photo. The shadow box tag adorns small timepieces, including pearls and flowers, detailed with glitter accents under an attached vintage bracelet.

STROKE OF GENIUS To protect meaningful memorabilia, cut out a small portion of a mat board, paint to distress, then use dimensional adhesive to create a one-of-a-kind embellishment.

STROKE OF GENIUS
Soften a black-and-white photo by overlaying a delicate piece of tulle. This gives the illusion that the flower girl is being viewed by the bride through her wedding veil.

When I Was a Flower Girl

A stunning combination of white patterned papers in an assortment of creamy shades, lace and tulle are used to create this flower girl page. The intricate beading, including the crystal borders, tiny beaded leaf embellishments, pearl studs and looped photo frame, are the spun-sugar icing on the page. A jeweled locket on a silver chain completes the picture.

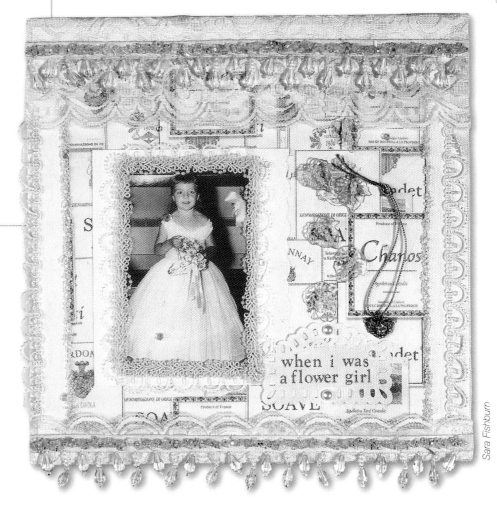

Sara Fishburn

Medieval Meanings of Stones

Crystals and beads are perfect embellishments for sophisticated white scrapbook pages. But in Medieval times, those fortunate enough to own gemstones had to be especially selective about which stones they wore, because a stone could affect the way you were perceived as well as your fate and fortune.

Jasper (red): Love, (green): Faith, (white): Gentleness
Emerald (green): Christian hope
Sapphire (blue): Heaven-bound
Chalcedony (pale blue, yellow, brown, white): Closeness to God
Sardonyx (red, rose, orange, blue, white, black): Chastity or humility
Chrysolite (sparkling pale green): Heavenly life
Beryl (green, yellow, blue, red, pink): Purification. Legend says it wards off sloth and evil spirits.
Chrysoprase (apple green): Virtue
Hyacinth (orange-yellow, orange-red, yellow-brown): God's grace
Amethyst (purple): Christ's martyrdom. Legend says it guards against drunkenness and protects against thieves.

Warm Up with Latte and Cocoa Whites

White is sensitive and must be handled with care. Under the right conditions clean, cool white can become almost snuggly. Coupled with earth tones or gentle pastels and mixed with a variety of shades and patterns, white can be used to scrapbook a wide variety of themes that are much less formal than traditional wedding pages.

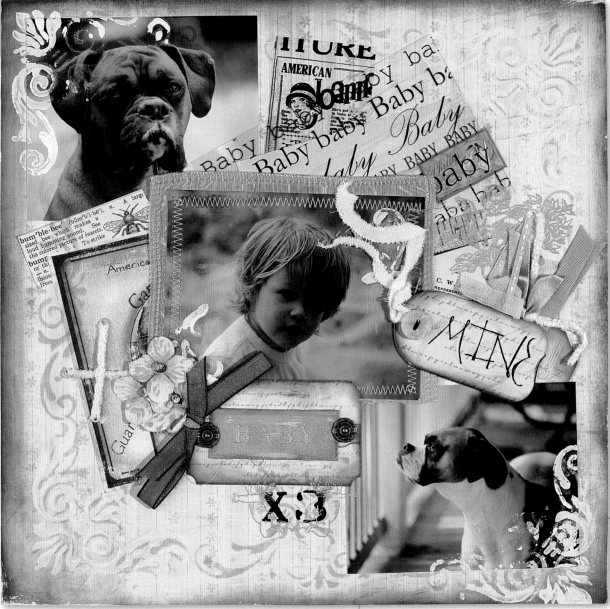

Laura McKinley

Baby X 3

Russet colored stamping creates warmth while flowers, fibers, ribbons, buttons and a fabric photo mat supply texture to this creamy white page. Printed transparencies supply much of the journaling when layered over patterned paper and under the photos.

 AH-HA! Double stamping, first with paint and then again with stamping ink, creates a stamped design with dimension.

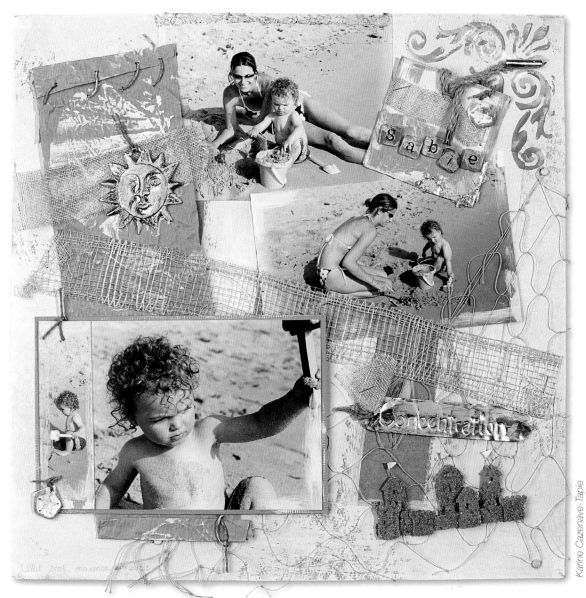

Karine Cazenave-Tapie

Concentration

Rich, brown earth tones add warmth to this silvery white beach scene. The white stamped and distressed background paper speaks "sun," while the textured brown paper blocks speak "warm summer sand." Loosely woven mesh stapled to the page and strung between brads, silver and tiny shell embellishments, as well as an inked and embellished journaling tag, add further dimension. The crowning glory? A tiny flag-adorned sand castle.

White Through The Ages

- In Egypt a Pharaoh wore a white crown to signify status.
- In India white was the color worn by the sacred caste.
- The chariot of the god Zeus is said to have been drawn by white horses.
- White lead makeup was used by women in the Middle Ages to lighten their skin; however, the beauty treatment often caused hair loss and illness.
- Since early in the 20th century doctors and nurses have worn white because it fails to hide dirt, which assures fewer germs and less infection.

Understand Shades of Black

The shades of night change from deep dusk to inky midnight and on to the gray of dawn. Black, like its counterpart white, comes in many shades and each has its own unique personality and purpose. The saturation and undertones of the color as well as the amount used dictate how the hue will impact a piece of artwork. While black is a terrific color and essential in a scrapbooker's color palette, working with it can be a challenge. Understanding it better results in scrapbook pages that are dramatically memorable.

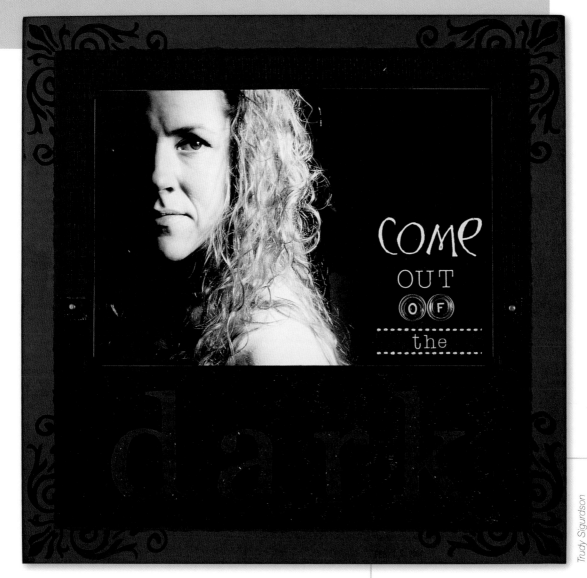

Trudy Sigurdson

Come Out of the Dark

A black stamped background layered with black lace and mesh create a dramatic foundation for an even more dramatic black-and-white photo. It is the combination of textures and slightly varied black shades that makes this page work. Elements, including the painted black title letters, typewriter keys, brads and ribbon, add a greater sense of dimension and help differentiate the different black shades.

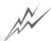 **AH-HA!** Using foam squares to pop up the title letters in the word "dark" creates shadows beneath the letters. This effect provides even more dimension, preventing the page from looking confusingly flat.

Cat in the Box

Black as the deep undercoat of a cat's fur, this page works perfectly with its furry theme. A text-patterned transparency lies on top of printed paper. The title, stamped on dark gray cardstock, is embossed, colorized and embossed again for visual dimension. Stickers and a reversed journaling block add the final touches.

New Car

Gray is just another shade of black and may seem more silvery than pitch if set next to a deeper and more saturated black hue. Metallic black paper, mounted over black cardstock, is given a shot of energy with stamped pink patterned paper, die cuts, flowers and ribbon embellishments. Distressing and stamping techniques help create a pink palette that is still somewhat rustic.

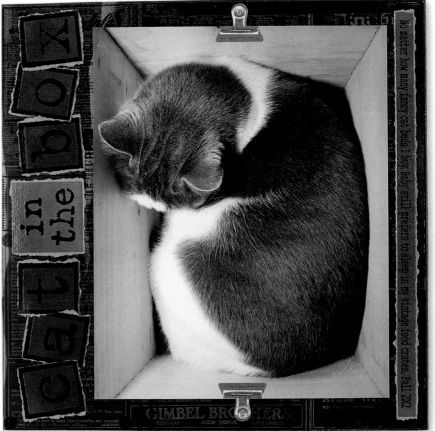

Erikia Ghumm, Photo: Brian Ghumm

Cherie Ward

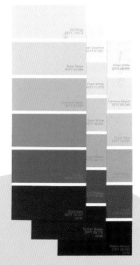

Anyone who has ever pulled together a black outfit from the store clearance rack knows, that not all blacks are created equal. Some are grayer, while others lean toward blue. Black, in all its tones, is a rich and varied color.

Soften Black Pages

Pitch black may be too harsh a choice for many scrapbooking themes. But that doesn't mean you can't work with this terrific palette. Learn to soften the effect of black through techniques such as inking and layering, in order to achieve a finished product that leans more heavily toward a "dawn" than "midnight" atmosphere.

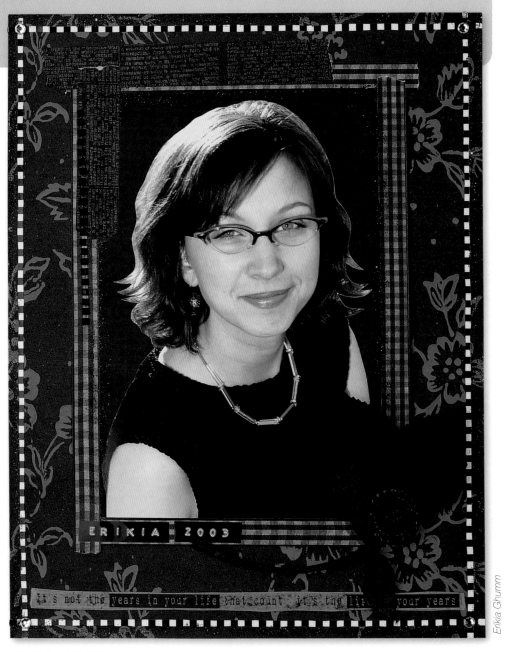

Erikia Ghumm

Erikia 2003

A combination of diverse floral, text and checkered black patterned papers softens the look and feel of this elegant black page. The gingham photo mat, torn paper edges and velvet leaf and button embellishments provide both dimension and sophisticated texture. Glitter and rhinestones, applied to the layout's edges and corners, add sparkle and seem to lift those portions of the page toward the viewer's eyes.

Luca & Marco

Black handmade paper, glossy and metallic cardstocks and mesh catch the light in very different ways, creating visual dimension and softening the look of this page. Blue fiber stitching, journaling and title blocks created of rich earth tone papers further warm up what might otherwise have been a very stark layout.

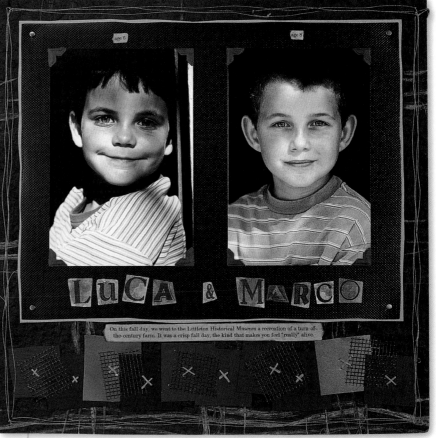

STROKE OF GENIUS

A meandering page border of delicate blue thread stitched to this layout helps create a boundary for other page elements, and its wispy nature further softens the mood of the page.

Erika Ghumm

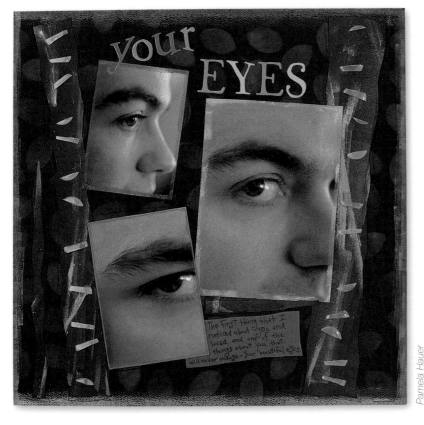

Pamela Hauer

Your Eyes

A variety of inks, rub-ons, pens and chalk are dabbed on this page, creating a surreal background for digitally-altered photos. The colorants create a "cloud," which seems to break up the expanse of a black cardstock background. Inked edges and a sticker title, as well as flowing inked paper strips, help guide the eyes through an off-kilter design.

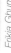

Black, By Any Other Name

Pure rich black has its place. It can be used to convey night, deep emotion or as upscale elegance. However, there are times when pure black may seem simply too stark for a scrapbook page. When photos or a page theme cry out for a color with black's emotional impact but with a slightly less absolute overtone, look to "near blacks" to fill the bill.

BEAUTY is a RADIANCE that originates from within and comes from INNER SECURITY and STRONG CHARACTER

Lakeside Park - AGE 3

Cathi Lindsay

Beauty is a Radiance

Gray, in its many shades, takes black's place on this digital lay-out just as the black-and-white photo finds a comfortable home on this largely monochromatic page. The murmur of pink in the "STRONG" journaling strip adds a whimsical touch of femininity.

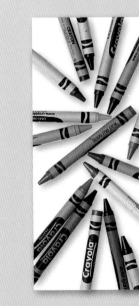

For Crying Out Crayola! No Gray in that First Box?

Gray takes over for black nicely on some scrapbook pages, but back in 1903 gray was not an option for school children around the country who wanted to use it to create their own special artwork. Why? Because those coveted containers of unblemished, unbroken and irresistible crayons that are a part of every go-to-school-supply kit didn't originally include the color gray. Goodness, how things have changed!

Colors Available in 1903 (8): Black, Brown, Orange, Violet, Blue, Green, Red, Yellow

Colors Available in 2003 (120) (Our Favorite Color Names—and kudos to those colorful folks who thought them up!): Atomic Tangerine, Laser Lemon, Screamin' Green, Wild Watermelon, Electric Lime, Purple Pizzazz, Razzle Dazzle Rose, Unmellow Yellow, Magic Mint, Radical Red, Sunglow, Neon Carrot, Asparagus, Macaroni and Cheese, Razzmatazz, Timber Wolf, Mauvelous, Tumbleweed, Purple Mountain's Majesty, Tickle Me Pink, Pink Flamingo, Fuzzy Wuzzy Brown, Pig Pink, and Inch Worm

Celebrate 50 Years

While a rich black palette would have worked well on this elegant celebratory page, deep blue cardstock, blue patterned papers and blue ribbon have stepped in to do an equally refined job. Gold photo corners, title and embellishments carry forth the traditional 50-year anniversary theme.

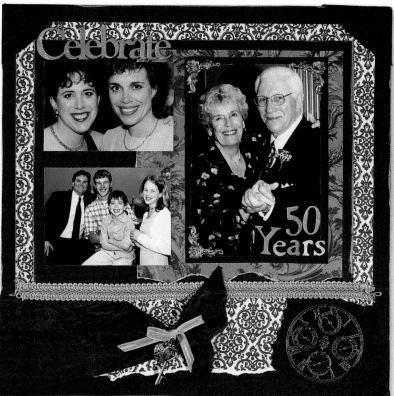

Tricia Rubens

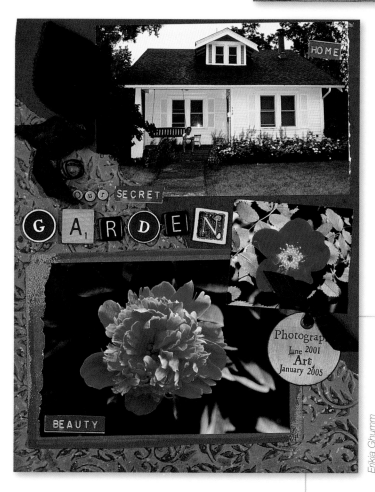

Erika Ghumm

Our Secret Garden

Deep green cardstock sprayed with brown ink deepens the mood and intensifies the black tone that highlights the beautiful bright pink and red garden flowers on this layout. Layered, colorized and embossed papers create a stunningly subtle overall effect, while a soft, velvet, leaf-adorned ribbon perfectly complements the embellished title and garden theme. Textured torn edges on photos and the use of decorative scissors on the outside edge of the cardstock add depth and call the eye to follow the visual flow of the layout.

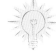

STROKE OF GENIUS

Create your own mixed-media title using polymer clay and stamps alongside pre-made embellishments for a playful yet elegant emphasis to page titles.

Circumvent the Black Hole of Doom

Black recedes visually, which makes it the perfect background for many layouts. But problems arise when a black background sucks photos and embellishments into the abyss, diminishing the impact of the photos. With care and creativity you can find an assortment of ways to utilize black while preserving the focus of your page—the photos.

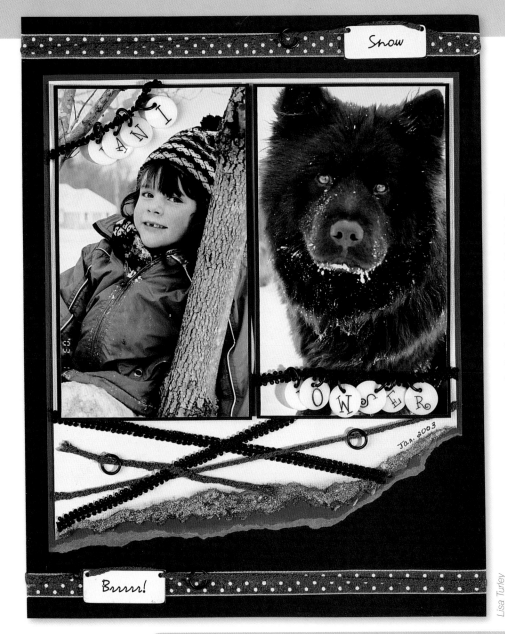

Lisa Turley

Danielle & Bowser

Not even a pitch black cardstock background can force these photos to retreat when they and their photo mat are wrapped in fuzzy and embellished fibers. The tactile fibers advance visually and pull the photos forward with them, allowing the background to fall away. Ribbon borders and metal embellishments frame the layout.

What is a Black Hole?

In astronomy, a black hole is a very dense object in space that has such a large mass and such a strong force of gravity that it pulls everything, including light, toward it. This creates an illusion of blackness from which nothing seems to escape. The term "black hole" was coined by American physicist, John Wheeler, in 1967.

Family

Prevent photos from disappearing into pitch black backgrounds by setting models against an expanse of white background. Place the photos behind a black window frame mat and accent with a hot and vibrant color. Lighter and hotter sections of the layout will advance visually while the black background recedes.

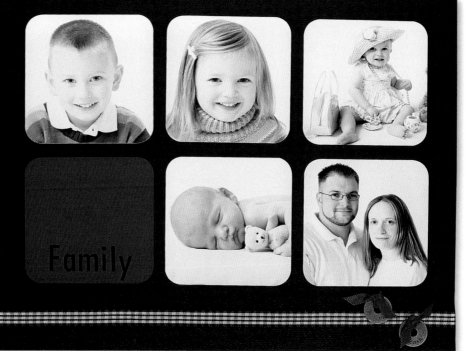

Lindsey Bloom, Photos: Amy Masser

B is For...

By skillfully using the "B" stencil to show a lighter and a darker background, the artist has created a feeling of dimension and space. The black "B" recedes while the light "B" creates a window for the viewer to look through. It is the dramatic difference between the two "B's" that creates depth. And it is that dimension that prevents the photos from becoming flat. Ribbons add a festive touch and even more dimension to the page.

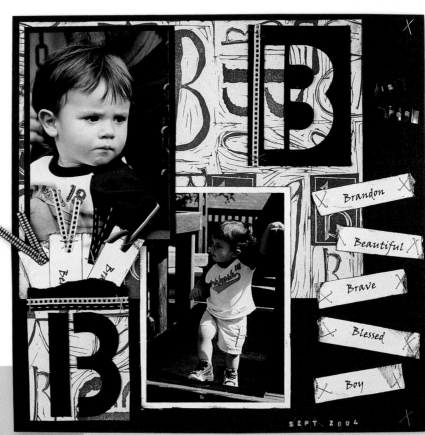

Sherry Wright

Don't Feed the Black Hole
- Frame photos with glitter or sparkly fibers.
- Fill the layout with many, many photos.
- Double, triple or quadruple mat photos with contrasting colors, or use oversized photo mats.
- Use vibrant photos awash with hot colors.
- Use light chalk or ink along photo edges.

Pick a Perfect Complement to Black and White

Simple and timeless, the little black dress and a good strand of pearls is the perfect combination for almost any occasion. Dress it up or dress it down, add a spunky hot pink purse, blue shoes and belt, or a mauve scarf, and you have a completely different outfit. Black and white are perfect for scrapbooking, because they wait patiently for a complementary color that defines the mood of the day.

simple and timeless
classically elegant
or fresh and funky

little black dress

Diane Hudson, Photo, Kelli Noto

Little Black Dress

Clean and classic, this page, featuring black and white cardstocks, goes perfectly with any accessory, including floral embellishments and a black ribbon.

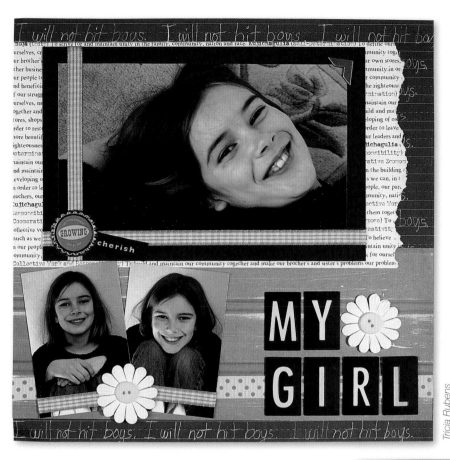

Tricia Rubens

My Girl

Black, white and green papers, ribbons and journaling set a scene that is fresh as spring. The green palette says "youth" when supported by black and white. Blooming daisy embellishments with lemony centers and a lime green and yellow bottle cap in completes the page.

Remember

A soft black background and white text treatment are all that is needed to create a tranquil atmosphere for this slumber page. The black-and-white photo has even more impact because of the coloration of the green train.

Meet Green

Associations: *Peace. Nature. Giants. Fertility. Jealousy.*
Cool Fact: *Eating green things like broccoli and spinach will help you lose weight, and the calming effects of the color also helps dieters resist impulsive binging.*
Worthless Fact: *Green is associated with the arts, and performers rest backstage in the "green room" prior to making their entrances because the color is calming.*
Green's Favorite Meal: *Green eggs and ham*
Green's LEAST Favorite Meal: *Frog's legs (so don't worry, Kermit)*
Green's Favorite Foreign Locale: *The Emerald City*
Closest Friends: *Yellow and Blue*

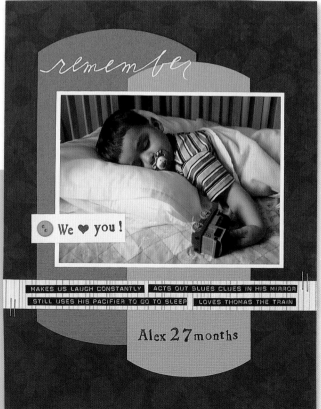

Wendy Inman

73

Meet Red

Associations: *Passion. Emotion. Fire. Energy.*

Cool Fact: *Red can raise blood pressure and make people lose track of time.*

Worthless Fact: *Chickens who wear red or rose colored contacts produce more eggs.*

Heads Up: *Red increases appetite, so if you're counting calories avoid red-checked tablecloths.*

Red Words: *"Red handed" (caught with the goods), "red-eye" (late night flight), "red-letter days" (special days—a term originally tied to days commemorating saints), without a "red cent" (poor), "red-carpet treatment" (special treatment denoting somebody's worth).*

Red's Favorite Song: *When the Red, Red Robin Comes Bob Bob Bobbin' Along*

Closest Friends: *Orange and Violet*

Pamela Frye Hauer, Photo: Ronnie Hauer

Naughty and Nice!

Red leopard print paper supports a series of independent collaged circles on this terrific page. Circles, cut from a variety of black-and-white patterned papers, are filled with assorted clip art images, stickers and jewels. Each circle contains a statement about a different aspect of the artist's personality.

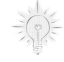

STROKE OF GENIUS A picture can speak a thousand words and the nine individual "pictures" featured on this page speak at least nine thousand words about the artist. No journaling could have told her story better.

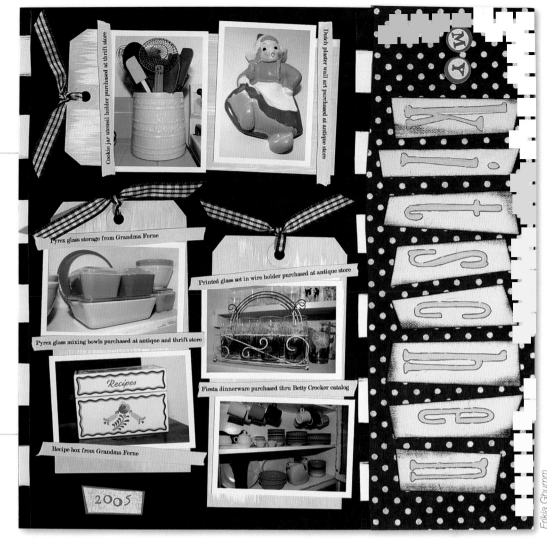

Erikia Ghumm

STROKE OF GENIUS

A creative and catchy title can set the mood for a scrapbook page. The "Kitschen" title on this layout speaks volumes about the quirky and clever personality of the artist.

Kitschen

A black-on-black stamped cardstock background provides visual dimension on this predominantly black page, which pushes other page elements to the fore. Hand-painted and stamped black-and-white papers create page borders that visually advance without changing the predominantly black palette of this layout. They support the yellow tag photo and journaling mats as well as the stamped title. A flourish of ribbons and a hint of red Bingo letters set a sunny kitchen mood.

Meet Yellow

Associations: *Sunshine. Spring. Innocent happiness.*
Cool Fact: *Yellow is used for "yield" signs and fire engines because it most easily attracts the human eye. Black type on a yellow background helps readers retain information.*
Worthless Fact: *Babies cry more in bright yellow rooms, and people fight more in yellow rooms.*
Bad News: *Gentlemen who prefer blondes may find natural ones increasingly rare because of the dominance of the dark-haired gene. (Strictly a hypothesis, so don't panic yet, guys.)*
Favorite Song: *Tie a Yellow Ribbon 'Round the Old Oak Tree*

Meet Blue

Associations: *Moody. Wise. Trustworthy*

Cool Fact: *As our eyes mature they develop more yellow prominence in the lenses. Blue, yellow's complementary color, counters that yellow and helps balance vision.*

Worthless Fact #1: *Blue has been ranked as the favorite color of those living in Western nations.*

Worthless Fact #2: *Shades of blue dye were created with the poison cyanide in the 19th century. When workers coming in contact with the poison began to die, creation of the dye was discontinued.*

Blue's Favorite Songs: *I'd Rather Be Blue Over You Than Happy With Somebody Else*

Blue's Closest Friends: *Indigo and Green*

I love this photo of The Stratosphere because it is from such a unique perspective. Lonnie and I had gone up to the top to ride the roller coaster and to see the amazing view (which took our breath away) . When we came back outside, I just

happened to look up and was really struck by the view point and just had to take a photo. Believe it or not, but I did not alter the colour of the sky. It really was the most amazing blue that I have ever seen. Las Vegas, January '03

• The •
Stratosphere

Trudy Sigurdson

Stratosphere

Sky blue soars on this boldly graphic page that lifts both the eyes and the heart. The light blue paper provides contrast and support to the brilliant blue in the photo. Clean lines, balanced journaling blocks and minimal embellishments in the form of a ribbon and brads allow the eye to settle and enjoy the dramatic lines of the building featured in the photo.

AH-HA! The long horizontal lines across the bottom of the page, created with black and white cardstocks, and a solid title help ground the photo. The lines actually provide a base on which the building seems to sit comfortably.

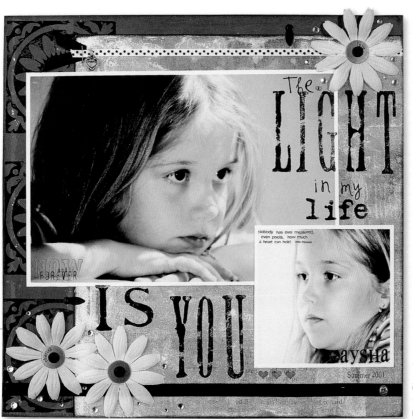

Trudy Sigurdson

The Light in My Life is You

The color purple can be royal or sentimental. It is always cool and often a little aloof, which allows the mesmerizing photos on this page to steal the show. The title, created with stamps and rub-ons, stands in as journaling as well. The stamped border on the side of the layout supplies a feminine decorative touch along with ribbons, a charm, flowers and randomly speckled rhinestones.

STROKE OF GENIUS If your brads are the wrong color and will fight with the palette you've chosen for your page, simply dip them in paint before using.

Outdoor Fun

Purple isn't just for girls. In fact, layered with bold black-and-white papers and an energetic photo, it can be called upon to create a very all-boy page. Playful fonts, stickers and tags support the theme.

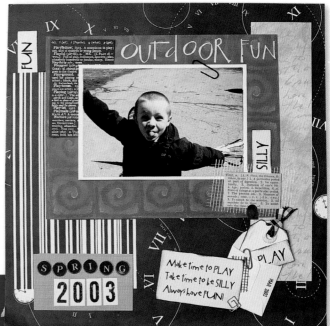

Nicole White

Meet Purple

Associations: *Royalty. Plums. Power. Spirituality.*
Cool Fact: *The Purple Heart (called the Badge of Military Merit) was designed by George Washington and awarded for the first time in 1783.*
Worthless Fact: *In 2001-2002 people from 200 countries chose purple over pink and aqua to be the new color for M&M's Brand candy.*
Purple's Favorite Song: *Flying Purple People Eater*
Purple's Favorite Movie Star: *Barney*

Meet Orange

Associations: *Florida. (It's almost impossible not to connect the color with the fruit!)*
Cool Fact: *Orange seems to make people feel hurried, which explains why it is used liberally by fast food restaurants and other establishments where proprietors want your table before you've finished that last fry.*
Worthless Fact: *The sun is actually orange but is referred to as "yellow," which makes orange feel unappreciated.*
Worth Noting: *Nothing rhymes with orange (or purple, for that matter).*
Closest Friends: *Red and Yellow*

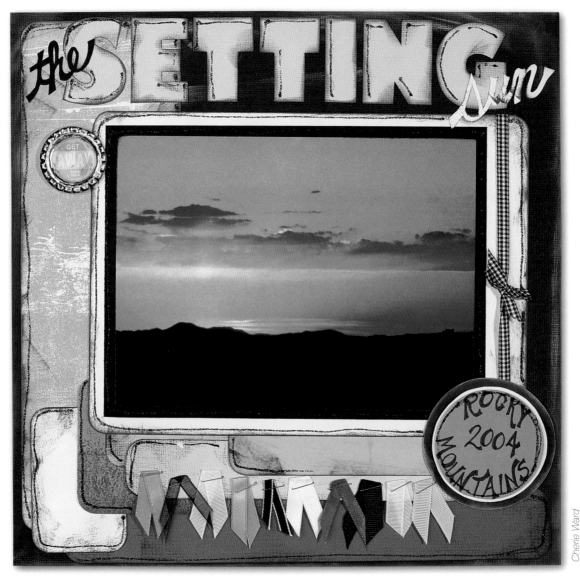

Cherie Ward

The Setting Sun

Orange, the color of a blazing sunset, becomes even more awesome when placed against a pure black background. Many shades of orange are featured on this page, which showcases everything from peach to tangerine to coppery orange browns. Ribbons, a bottle cap and a glittery title add interest to this flaming layout that seems to capture the passionate soul of the color it embraces.

Copie Conforme

Overlapping deep peachy pink and black patterned papers are the focus of this page. Heavy black inking along the edges of all page elements creates drama. Handmade stenciled letter "C's" cut from black and pink cardstocks are double matted on contrasting colors of textured cardstock. Lightly sanded metal letters spell out the page title, and ribbons and buttons add accent.

Manon Dufour

Keri Voigt

Special

This sentimental page is defined by the pink die-cut block in the lower left corner. While the punched patterned paper circles and photo mat help balance the page, it is that pink element that controls the mood of the piece.

Meet Pink

Pink Associations: *Babies. Females. Gentle love.Blushes.*
Interesting Fact: *The flamingo acquires its bright pink color from the carotene in its diet of shrimp and other crustaceans. If the diet is low in carotene, the feathers become white.*
Worthless Fact: *The first popular bubble gum was colored pink, because that was the only colorant the inventor had on hand. Because of the product's success, the color stuck.*
Pink's Inquiring Mind Wants To Know: *Why are they called "pinking shears"?*
Pink's Favorite Song From a Disney Film: *Pink Elephants On Parade (Dumbo)*

79

Too Hot to Handle
working with orange, yellow, red and pink

A burger spitting on an open grill

The last blazing eye-squinting flare
of a dying sunset

Blood red roses with satin bellies
and velvet skins

Drum beats. Heart beats.
Whirl. Sweat. Dance.

Sizzle

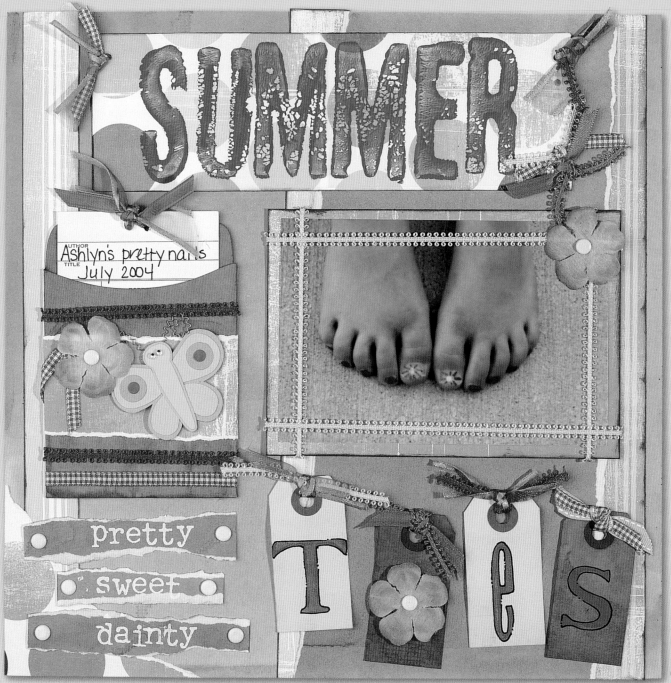

SUMMER

AUTHOR
TITLE
Ashlyn's pretty nails
July 2004

pretty
sweet
dainty

T O E S

Meet Sizzling Orange, Yellow, Red and Pink

Flaming, sizzling, heart-racing colors of orange, yellow, red and pink actually do speed up metabolism. They lift the spirits and make us want to take off our shoes and whirl. Because these colors throw our emotions into high gear they are the perfect choice for scrapbooking pages that are action-packed. Hot colors trigger passionate feelings ranging from fury to adoration. By mixing hot colors with cooler shades or with earth tones, you can open up a wide spectrum of possibilities for scrapbooking themes that span topics and seasons.

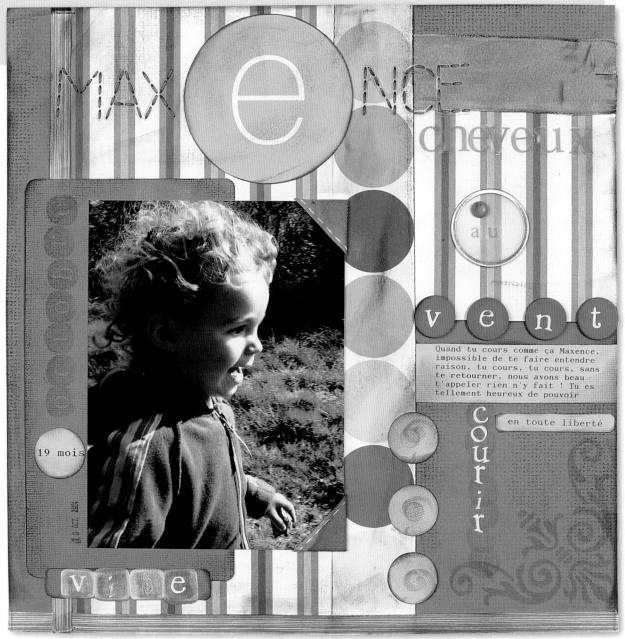

Quand tu cours comme ça Maxence, impossible de te faire entendre raison, tu cours, tu cours, sans te retourner, nous avons beau t'appeler rien n'y fait ! Tu es tellement heureux de pouvoir

en toute liberté

19 mois

Maxence

Inked orange cardstock overlaid with inked and stamped patterned papers creates a page so hot that the blue complementary elements are hard pressed to cool things down. An orange ribbon, creative lettering and an embellished metal-rimmed tag have a heyday on this page.

And it was Spring

Hot colored patterned papers over hot pink cardstock set this page on fire. Crisscrossed ribbons and vibrant title letters add their own heat to the page, while a large bouquet of paper flowers slips boldly from the scrapbook page and into the photo to echo the floral pattern in the model's skirt.

AH-HA! The small "Leaves and Trees" book is an interesting piece of memorabilia and the title also provides a bit of journaling, while introducing a shady brown island that is restful for the eyes.

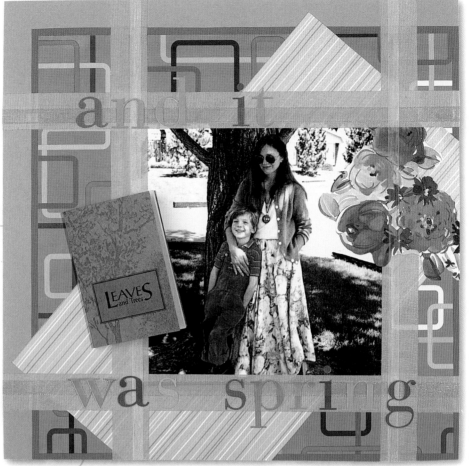

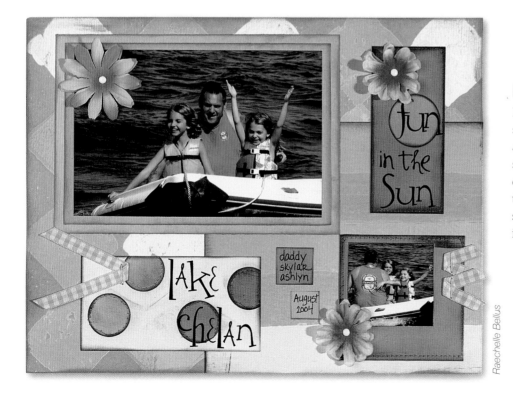

Fun in the Sun

Patterned paper in colors that say "fun" are layered beneath a double-matted photo on this summery page. Rub-on letters decorate festive stickers for the title. Ribbons, flowers, brads and staples adorn the layout, which is hot as a summer boat ride.

Handle Flaring Sunset Pages

It's that time of the day. Time to squint your eyes and prepare for that last searing burst of drama known as a sunset—a unique mixture of reds, oranges, yellows, purples and sometimes a shot of green. Draw on that palette to create scrapbook pages that mesmerize and captivate.

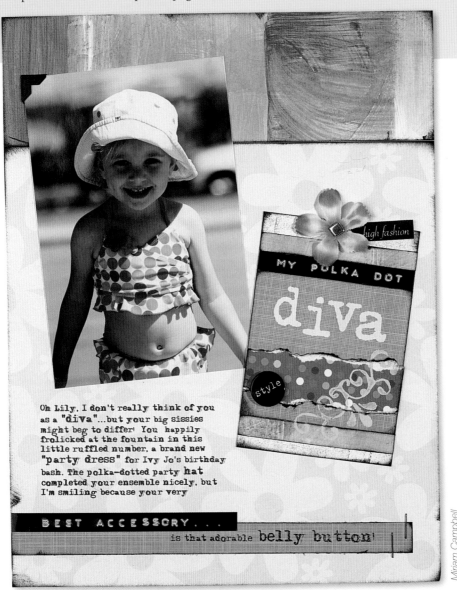

My Polka Dot Diva

The light colored patterned floral paper forces other hotter elements on the page to advance. The inking around paper elements and journaling tags actually creates a sense of shadow. The illusion visually lifts the bolder colored page elements off the background paper.

Orange Through the Ages

Helen of Troy was forced to wear orange to represent her tainted state after her affair with Paris.

Orange was a preferred hair color by women in ancient Rome, who dyed their hair with henna. The hair color was also favored by British women in the 16th century, who dyed their hair to look more like Queen Elizabeth I.

Orange was considered the color of deceit and disloyalty in the Middle Ages.

In ancient China, deep orange elixirs were believed to make consumers blissful.

The color orange has been linked to war, as British soldiers working for King Henry III wore capes marked with orange crosses.

Madison's New Do

Lightly sanded patterned background paper is layered with inked cardstock, crumpled paper scraps, mesh and large circles cut from patterned paper to form the basis of this brilliant page. Metallic embellishments call attention to the brown envelope and ribbon-adorned tag.

AH-HA! The brown envelope on the page's lower left corner offers visual relief from the wild combinations of colors on the rest of the page. It is an essential element on a layout that simply bursts with energy.

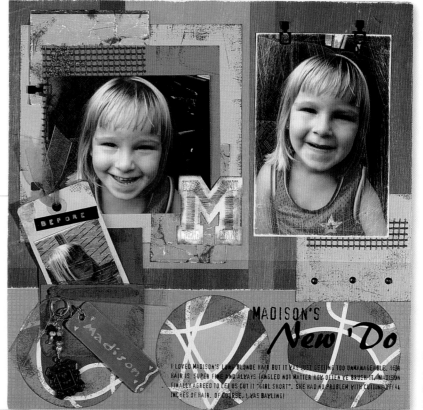

Lily Goldsmith

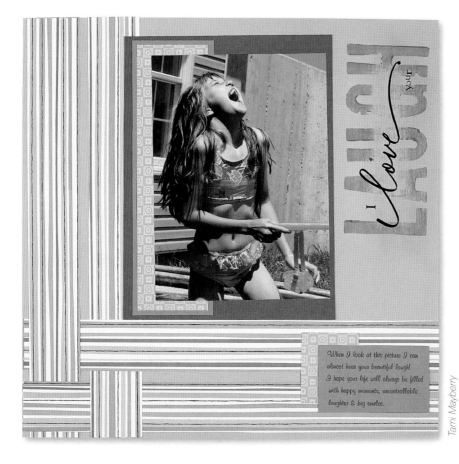

Tami Mayberry

Laugh

Woven strips of vibrantly festive patterned paper on a screaming orange cardstock background carry the mood for this layout. The photo, mounted on sections of both patterned and solid papers, holds center stage, while a journaling block and corresponding patterned paper mat in the bottom right corner balance the layout. The title, stamped and then sanded, supports a rub-on sentiment.

85

Calm the Burn

It's so hot it hurts, and that burn is calling for a little cooling down. Take the sizzle out of too-hot-for-their-own-good scrapbook pages with soothing earth tones and other calming colors. You'll watch the pages turn from "high noon on the beach" to "late afternoon under the umbrella," moods that will detract nothing from the energetic fun.

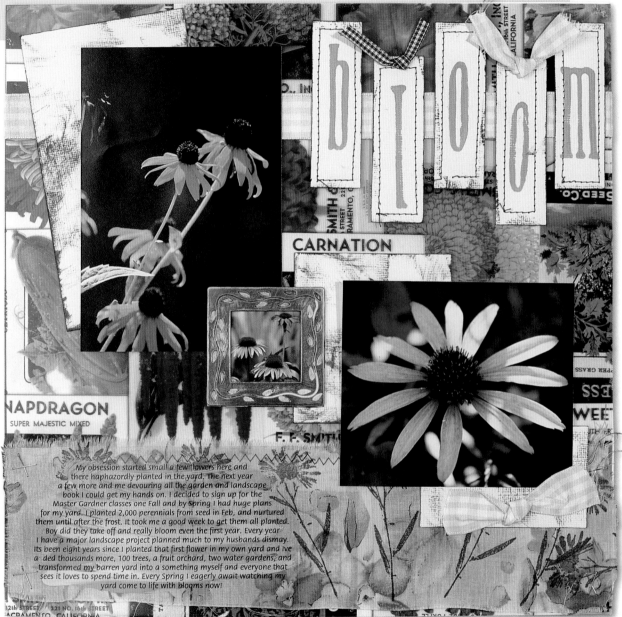

Sherry Wright

Bloom

This page, inviting as a mid-summer garden, is created with a collage of stitched distressed papers, fabric and photos. A strip of fabric stamped with a flower design borders the page bottom, while ribbon-adorned, stamped title blocks visually hold up the top of the page. Additional ribbons and a metallic frame complete the picture.

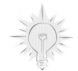

STROKE OF GENIUS The well-worn pink ribbon that adorns the journaling tag on this page once graced the young ballerina's toe shoe. What a great way to preserve a piece of memorabilia!

Bottoms Up

A wide variety of layered and stitched patterned papers in complementary colors forms the background for this toe-tapping layout. The stenciled "B" is frosted with self-adhesive beads to form part of the hand-cut title. A Degas charm and a silk flower dress up the page.

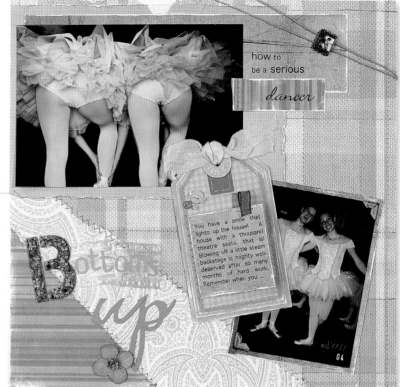

how to be a **serious** *dancer*

You have a smile that lights up the house! A house with a thousand theatre seats, that is! Blowing off a little steam backstage is mighty well-deserved after so many months of hard work. Remember when you ...

Miriam Campbell

Shadows

"Don't be afraid of shadows, they just tell us that there's a light somewhere nearby." unknown

Steven and I during a walk in the pasture. Summer '04.

Rhonda Palmer

Shadows

Quick and easy color blocking creates a background for this dramatic photo. Bold journaling and limited embellishment add to the page's poignant statement.

AH-HA MOMENT The lengthened shadows in this photograph predict the inevitable encroachment of night. The color choices support that story, speaking strongly of that magic moment when sunset meets darkness.

Get Sizzle from Combustive Neons

Think: a quart of rainbow sherbet ice cream zapped with a laser gun. It glows, it screams and it's called neon. Add a snap of neon to an already hot page, and you've got something that can't be equaled in volume or impact.

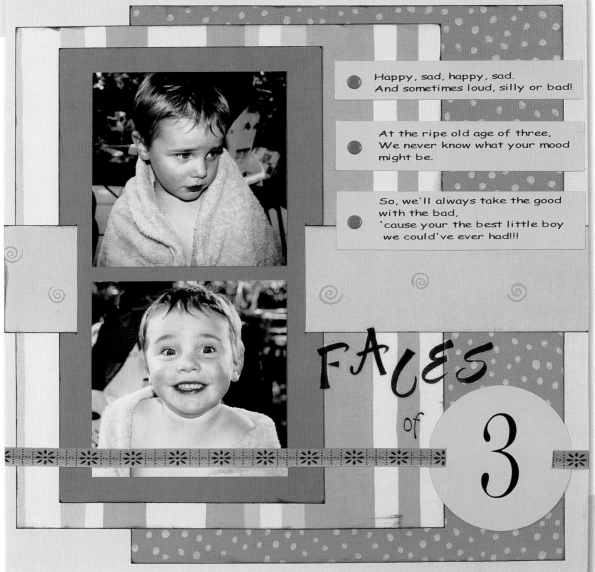

Happy, sad, happy, sad.
And sometimes loud, silly or bad!

At the ripe old age of three,
We never know what your mood
might be.

So, we'll always take the good
with the bad,
'cause your the best little boy
we could've ever had!!!

FACES of 3

Vicki Boutin

Faces of Three

Vivid blocks and strips of patterned paper are mounted on an equally vivid yellow background to form this fearlessly colorful page. Paper edges, including the orange photo mat, are inked to add distinction between page elements. Neon green journaling blocks decorated with orange snaps, rub-on title letters and a decorative ribbon tie page elements together.

Neon Knowledge

Neon, a rare inert gas, was discovered in 1898 by Sir William Ramsey and M.W. Travers. It is colorless but glows reddish orange in an electric discharge and is used in display and television tubes. The term grew in popularity in the 1960s when "neon" colored clothing—materials with extremely bright colors—became the rage. Oh, wow, man, neon was cool!

Girl Friends

Vibrant neon patterned papers, inked and ripped, lie under a friendly black-and-white photo. A title made of wild and wonderful stickers, page pebbles, Dymo label and a metal-rimmed tag are complemented by stamped journaling blocks. Colorful fibers and ribbons decorate the quote tag and photo mat.

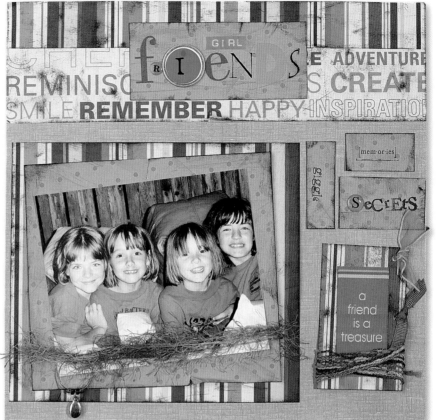

Michelle Miller

Weston Fair

Neon orange, turquoise, yellow and purple make up the palette for this adventurous page. The double-matted primary photo lies under the transparency, while the supporting photo is mounted on top. Sticker letters form a playful title, and colorful ribbons and fiber complete the picture.

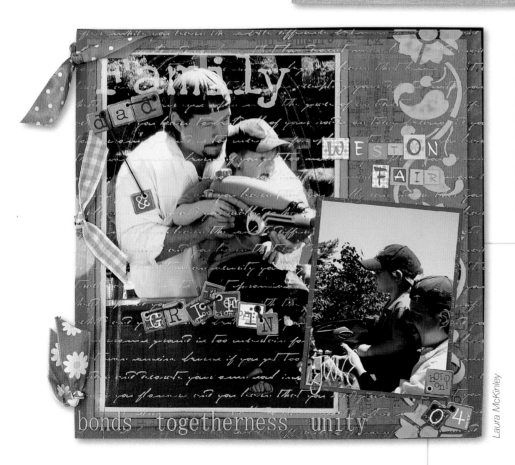

Laura McKinley

AH-HA! Mounting a photo beneath a transparency and another on top creates a perception of depth which gives the layout even more appeal.

Make Hot Pinks Matter

Hot pink can't be ignored. Whether heated up or cooled down, it still pops. Use hot pink for energetic pages or massage it to support colors in your images. It is hard to take this color down even a notch, so reserve it for those pages that need to be freed to make as much noise as possible.

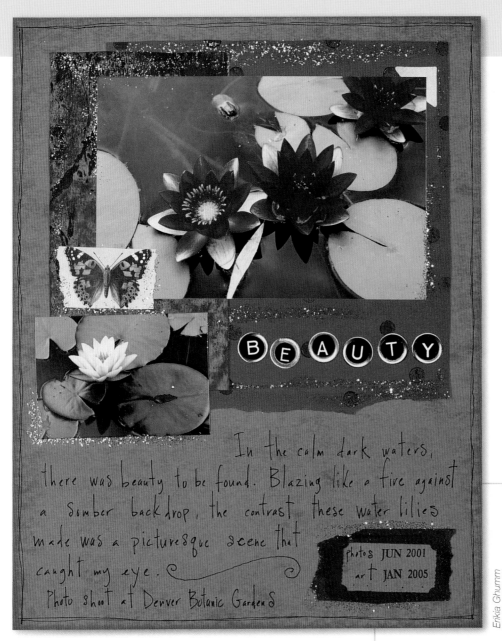

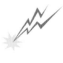

Erikia Ghumm

Beauty

A too-pink-to-be-true cardstock background is made even more interesting when layered with vibrant hand-painted and stamped papers. Boisterous floral photos surrounded by glitter glue hold their own against this dominating palette. Hand journaling and a title made of typewriter key stickers complete the page.

AH HA! When creating stamped or painted papers for one project, save the leftover bits and pieces. You may find a terrific place to utilize these remnants as demonstrated on this page.

Playing with Dad and Mom

A single patterned paper and two vibrant colors of cardstock are all it takes to create the palette for this high-energy layout. Black photo mats give the photos a place to rest. Stamped and rub-on letters join forces to create the title and journaled sentiments. Bottle caps and ribbon add the finishing touches.

Pink Through the Ages

The pink walls of a famous Scottish castle were made from paint mixed by combining white paint and pig's blood, but in America, pink was historically made by mixing milk and red paint.

In ancient times an Indian Maharaja is said to have built an entire city out of pink stone.

Magenta became the fashion color of choice when used extensively by the Russian Ballet in performances prior to WWI. It became all the rage once again in the 1950s.

Karine Cazenave-Tapie

Use Pink and Purple To Flatter

Ask a little girl what her favorite color is, and she's likely to name either pink or purple. Invite those two colors to come together on a scrapbook page featuring your favorite little princess, and you'll have a piece of artwork she's sure to cherish almost as much as you do. Combine less saturated shades, or mix gentle tones with heavily saturated hues, for an unlimited number of unique effects.

Patti Milazzo

The Price of Beauty

Delicate text patterned paper layered over inked patterned papers and cardstock support inked, matted and mounted photos of a glowing beauty. Journaling appears inside the purple folder, which is tucked under the pink paper strip at the bottom left corner of the layout. The title is printed on transparencies. Buttons, a flower and ribbons add a super feminine touch.

STROKE OF GENIUS The bows tied through punched holes at the right of the focal photo are cut from fabric rather than snipped from rolls of ribbon. Their fuzzy and frayed texture reflects that of the fabric rollers in the model's hair.

Live, Laugh, Love

Ripped strips of patterned paper and pink cardstock laid over a gentle purple patterned paper background create a foundation for this sweet page. The photo is triple matted, first on brown and then on patterned paper and cardstock before being wrapped with yarn and adorned with a tag and button. A stenciled letter "L," punched squares, buttons and ribbon embellish a chalked block. Stamped title letters are overlaid with vellum phrases.

STROKE OF GENIUS When stamping the title directly onto the intricate, pieced paper background the artist ended up with a stamping disaster. Rather than toss the artwork and start over, she restamped the title letters on solid pink paper. The paper was then cut into blocks, which were adhered in place to cover the earlier stamping disaster.

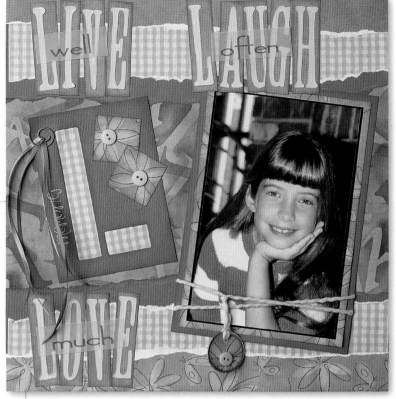

Madeline Fox

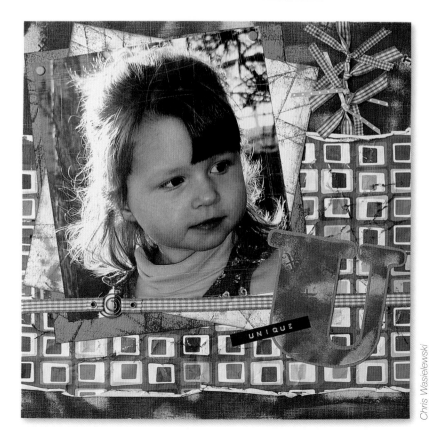

Chris Wasielewski

Unique

Crumpled, torn and inked patterned papers over a sanded and inked textured background give this unique page its perfect rumpled look and appeal. The large "U," cut from stamped paper, bright ribbons and a swirl buckle, Dymo label and a compellingly strong photo work together with the distressed background to create an engaging layout.

93

Make the Most of Gossamer Soft Pinks

Pinks as soft as a baby blanket or the blush of a toddler's cheek call out to be brought together on pages featuring very young children. Used with black-and-white photos, they are classy and classical. But mixed with spicy colored pictures, they provide a neutral background that allows the photo to shine.

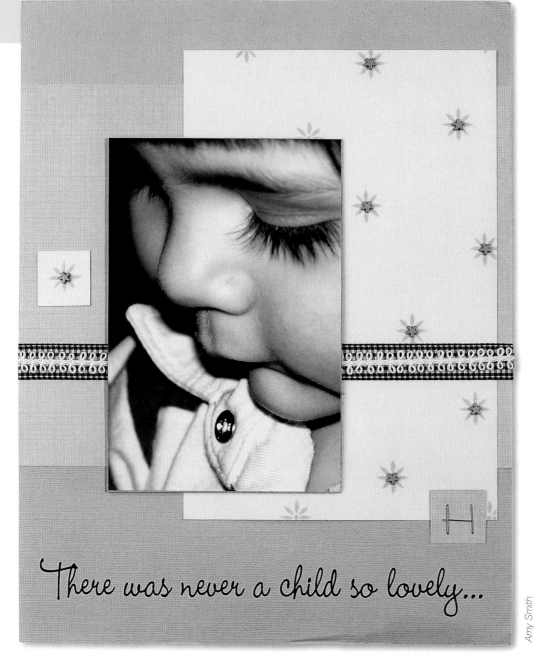

Amy Smith

There Was Never a Child so Lovely...

Textured cardstock and patterned paper in colors as gentle as a sigh create the perfect mood for this pensive photo. Peach, pink and pale green work together sweetly. Staples, tiny star tacks, a layered ribbon strip and punched squares add a dimensional touch.

Meganne

Blocks of coordinating pale green and cream patterned paper laid over a pale pink textured cardstock background help define this classically sweet baby page. A pale pink photo mat, flowers and ribbons, rickrack and a delicate tag support the almost fragile color palette. The title letter blocks are carefully sliced so that ribbon can be slipped through before being suspended from the horizontal ribbon and adhered to the page.

STROKE OF GENIUS The photo is not vintage, but the gown the model is wearing is a family heirloom. The importance of this handing-down of christening gowns is reinforced by the faux vintage sticker appearing on the page.

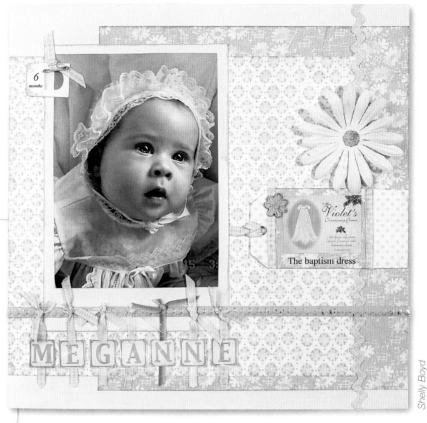

Shelly Boyd

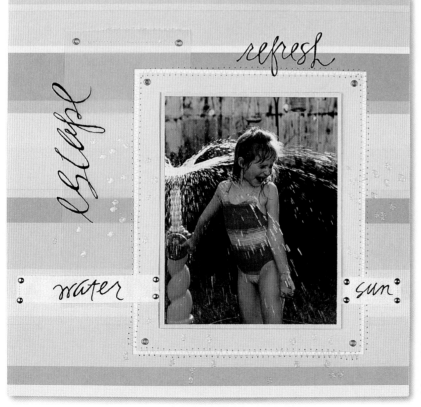

Johanna Peterson

Refresh

Couple striped patterned paper of powder soft pink and pastel shades of orange and yellow with gentle cardstock photo mats and you have a page that is truly fresh. Vellum, stitching, brads, rub-on words and faux water droplets join an utterly fantastic photo to complete the layout.

Serve Up Tutti Frutti Colors

Tutti frutti fresh and juicy colors borrow something from more vibrant shades and something from gentle pastels. These hybrid pinks are often saturated and rich, but lack the "bite" of their hotter pink relatives. Use tutti frutti pinks with pure saturated hues.

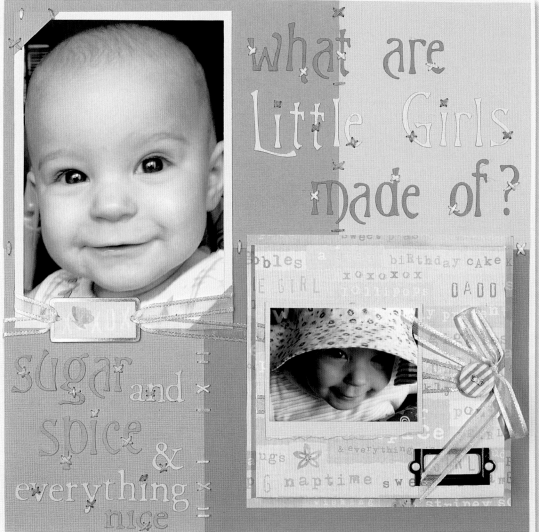

Cindy Smith

Sugar and Spice

Simple and simply powerful, this compelling page relies on a textured cardstock background for its appeal. Delicate letter stickers and even more delicate hand-stitching of select letters keeps the focus of the page on the sentiment. A handmade photo album, decorated with sunny patterned paper, a photo, button, ribbon and bookplate, adds interest and holds additional photos.

Lynne Rigazio Mau

25 Days Old

Ripped and inked pattern paper layered across the page creates the foundation for this gentle layout. The cream colored mat matches the tiny outfit and bed linens of the model. A title, created with stamping and rub-ons, is decorated with silk ribbons. Charms, trim, twine and a silk flower wrap up the package.

Giggle

A stitched color-blocked background of sherbet patterned paper plays on the colors of the beach ball and outfits seen in the photo. The papers have the look of textured fabric, and the sewn seams add to the illusion that this is actually a piece of summer clothing. Rub-on words and boldly stamped names complete the picture.

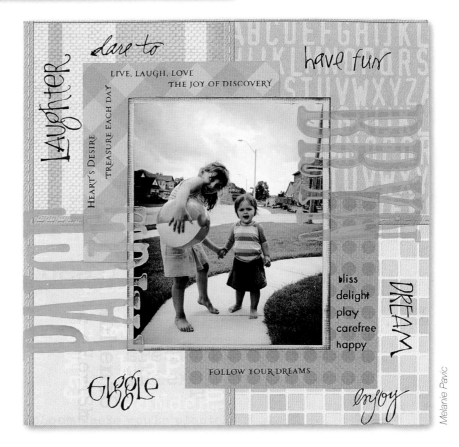

Melanie Pavic

97

Appreciate the Many Faces of Red

Red, the most intense color in the artist's pallet, is believed to be the first color perceived at birth. It has a strong physiological effect upon human anatomy and stimulates heavier breathing and a faster heartbeat. Patients with head injuries, who suffer from temporary color-blindness, respond to the color red before they are able to recognize any other colors. Red heats up scrapbook pages like no other color, and because of the wide range of shades, it can be used with most photos and themes.

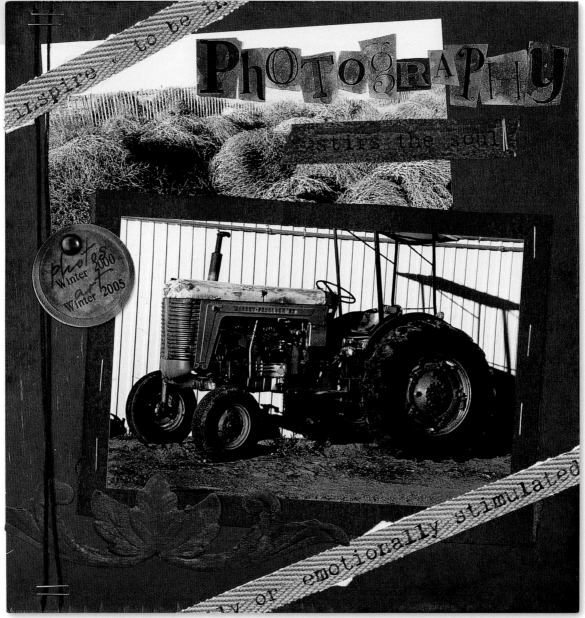

Erikia Ghumm, Photo: Brian Ghumm

Photography Stirs the Soul

Wood printed patterned paper and a brick red photo mat create the rustic background for this country page. The rusty red palette is supported by the "stirs the soul" portion of the title block and the journaling on the metal-rimmed tag. Printed twill tape, letter and decorative stickers, twine and inking add to the down-home look of the page.

You Inspire Me

Fire engine red takes over on this musical page. Patterned paper, musical transparencies, and a photo cropped to emphasize the color of the guitar, carry the palette. A stitched leather band, index tabs, stencil stickers, brads and abbreviated journaling blocks balance the page and supply a shot of clean, clear white, which gives the artwork dimension.

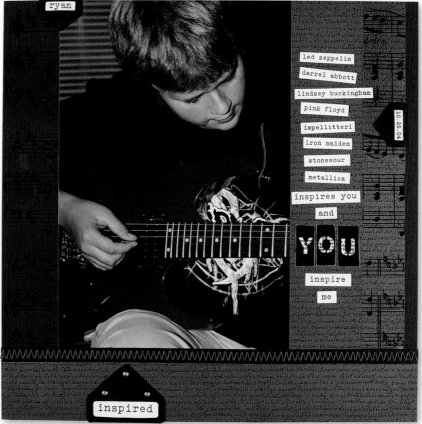

Diana Hudson

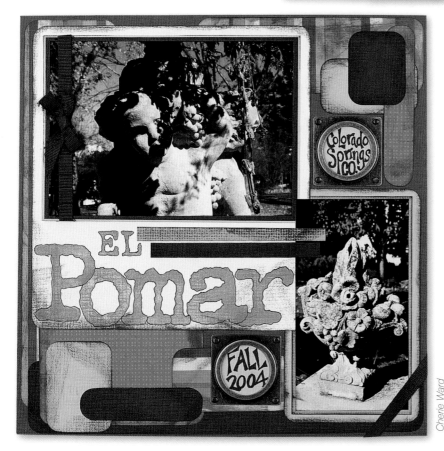

Cherie Ward

El Pomar

Rich red inked, textured cardstocks and patterned papers are layered over a tomato red cardstock background on this artistic page. A blue stamped title is outlined in dark ink for extra impact. Metallic frames hold journaling, and red ribbons tie up the stunning scene.

99

Celebrate What's Black, White and Red All Over

Red loves to fling itself right off a page. That's one of its more gregarious qualities. Give it a knee up by coupling it with shades of black and milky white. Use patterned paper, stamps and other embellishments to provide a contrasting background for this great color.

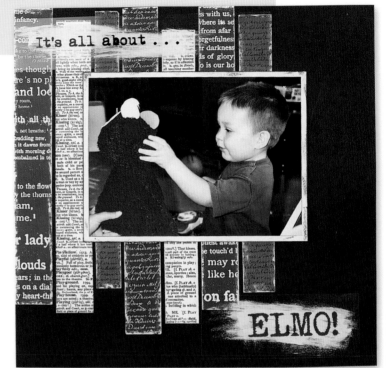

It's All About Elmo!

Black, white and red patterned paper strips on top of a pure black background set the scene for this endearing page. A black-and-white photo allows the colorized character, Elmo, to stand out. The title, printed on a transparency, is colorized with acrylic paint before being mounted.

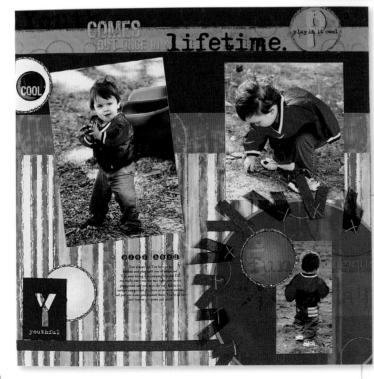

Play it Cool

Boisterous red patterned paper layered over a black textured background forms the playful backdrop for this page. A printed transparency serves as a title, while a "Y" letter stencil, stickers and journaling express the rest of the sentiments. A large circle cut from black patterned paper grounds the lower right corner of the page.

AH-HA! A terrific page was made even better by the creative use of ribbons. The folded and stapled ribbons surrounding the large circular shape in the lower right corner add that extra something without which the layout would have been pleasant but perhaps not as powerful.

Hard at Work

A fire engine red sweater dictates the palette for this busy-as-a-boy page. Red patterned paper covered with a printed transparency is mounted on a black cardstock block before being mounted on earthy patterned paper and black textured cardstock. A block title, buttons, a bottle cap, snaps and wire add interest to the page. The miniature file folder, decorated with a supporting photo, holds journaling.

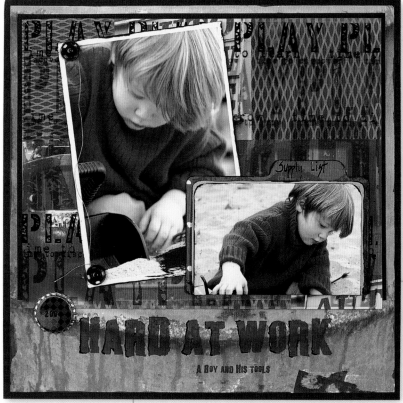

Laura McKinley

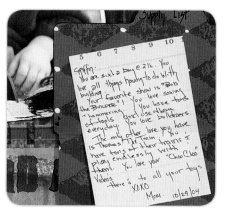

AH-HA! The miniature file folder is attached to the background transparency with an adhesive application machine, assuring a tight bond and a finished look.

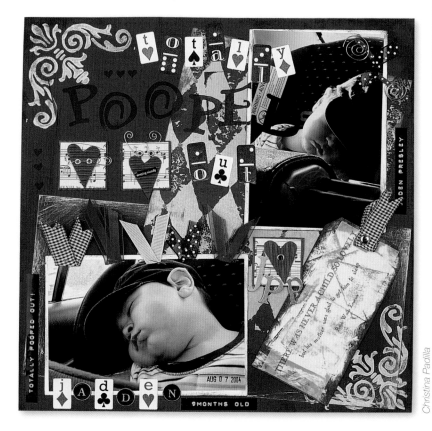

Christina Padilla

Totally Pooped Out

Brilliant red textured cardstock, inked and stamped, forms the basis for this tuckered-out page. A tan and black paper block and distressed and stamped black cardstock block cool off the fire just a bit. Beguiling playing card stickers, ribbons, Dymo labels, vellum journaled quote, brads, swirls, staples and other embellishments assure that this page is nothing to snore over.

Finesse Hot Red Pages

Red is flame and fury. It is one of the hottest colors out there. But upon occasion, when too much red might actually be too much of a good thing, look for ways to lighten its touch. Minimize the amount you use or select a cool complementary color to draw the eye away from the red.

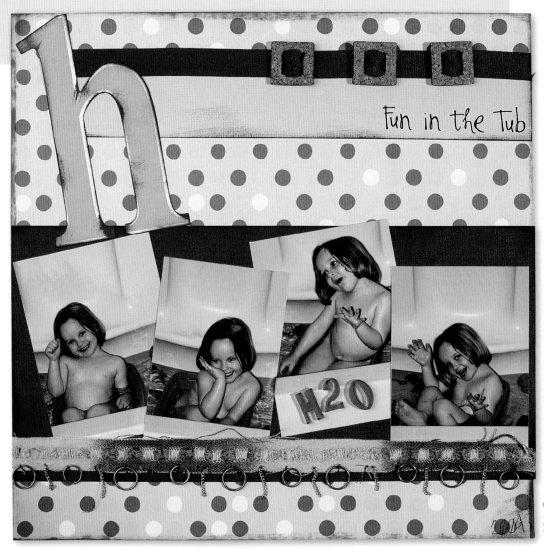

Misty Posey

Fun In the Tub

An inked red background and vibrant yellow patterned paper are cooled off just a tad because of the dominant blue inked letter "h." Blue looped ribbon, the blue "H20" and the blue tint to the photos chill things off.

Red Through the Ages

Red is used in Chinese New Year celebrations and for Chinese bridal dresses.

Red was worn exclusively by nobility during medieval times as a sign of power.

Red was considered magical in the Dutch East Indies, and so blood from a red hen was used to write love spells.

For ancient Romans, a red flag signaled that battle was to commence.

In the second century, a Greek physician urged that all men eat red food and drink red liquid to benefit their confidence and dispositions.

Red amulets have been worn throughout history in many cultures to make the wearer more invincible.

Sisters

Cool down a red page by masking the expanse with creamy and cool accent colors. A torn and inked cream paper block is mounted on textured red cardstock. Distressed and crumpled patterned paper strips and a pink ribbon stretch across the cream island. The beguiling photo, mounted on pale pink cardstock, a title block made of inked colored cardstocks, ribbon, flowers, brads and a metal phrase plate draw the eye toward the center of the page and away from the smoking red border.

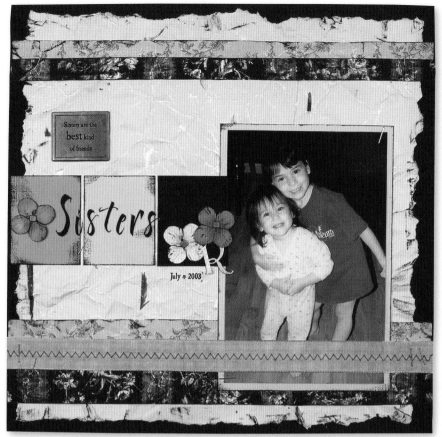

Laura Alpuché

Explore Life

Reap the energetic benefits of red without using up your hoard of red papers by featuring photos that include elements of red in the shots. Mat photo on red cardstock. Set additional circular photos beneath a stamped transparency strip. Finish with a blood red title and epoxy sticker.

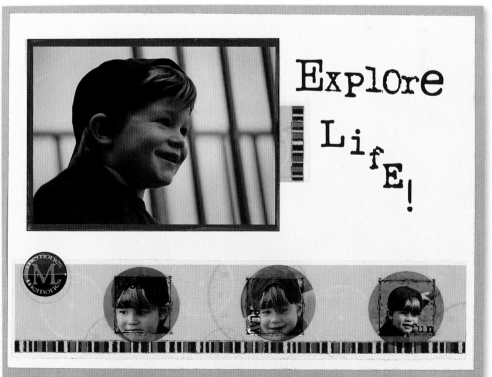

Laura McKinley

Have Yourself a Tasteful Red Christmas

Red holidays such as Christmas and Valentine's Day can be scrapbooked tastefully by carefully selecting the shades of red used. Complementary colors that are interesting and unusual help prevent red holiday pages from being overwhelmed with saturated and vibrant shades of cherry that detract from the artistic quality of the layout.

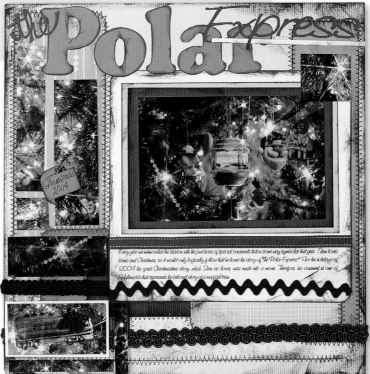

Cherie Ward

Polar Express

Inked, layered and stitched patterned papers and cardstock in shades of cream, pink, white, green and red create the palette for this holiday page. Both the unusual shades of these colors and the inking of the papers help create a page that conveys the holiday spirit and is unique and artistic. Rickrack in deeper shades embellish the layout.

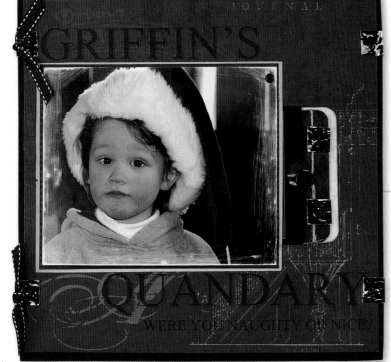

Laura McKinley

Griffin's Quandary

This irresistible Christmas page is a pool of rich, warm, ruddy red, interrupted only by a captivating photo and a few supporting embellishments. The file folder sleeve, covered in patterned paper and slipped behind the photo, shares "The Facts" as they pertain to the "naughty or nice" question. Title words are printed directly onto the patterned background paper.

AH-HA! Create metal embellishments by inking a long narrow piece of metal. When dry, sand over the ink. Cut the metal piece to size, bend around the edges of a page, and attach with brads.

Christmas 1955

This heritage scrapbook page utilizes a variety of patterned papers in colors from red to gold and brown to mossy green. The palette is warm and conveys mellowed age, a theme reinforced by distressed Christmas cards layered over patterned papers, coppery embellishments and woven lace. The black-and-white heritage photo says "vintage" all the way.

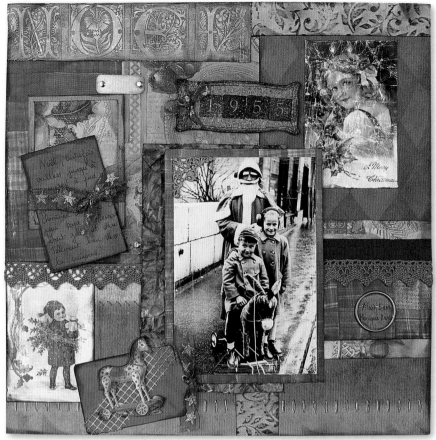

Karine Cavenave-Tapie

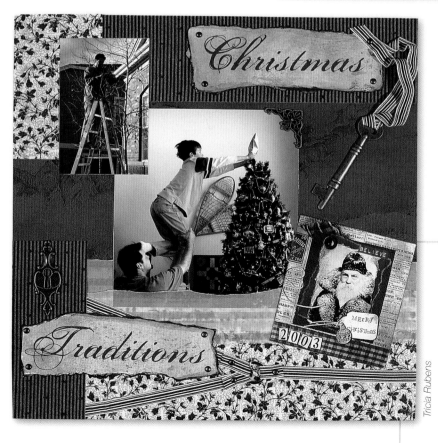

Tricia Rubens

Christmas Traditions

Patterned papers that include rich warm reds, greens and cream are patched together like a comfy quilt on this holiday page. Inked title blocks and an assortment of metallic embellishments, which include photo corners, brads and charms, add a vintage feel. The large metal key, tied with a ribbon, draws the eye from the upper title block directly to the photo.

AH-HA! Create the effect of a randomly folded ribbon by looping the ribbon strip through the key hole. Arrange the ribbon so that it appears to have been casually dropped onto the page. Adhere the folds in place to prevent movement.

Red Hot Holiday Pages That Break the Rules

Red is for Christmas. Brown and gold are for Thanksgiving. Pastels are for Easter. There's no question about it—color and occasion are closely linked. However, familiar color combinations that help us capture and convey the beauty of traditions are not hard and fast rules. When your photos or your creative vision cry out to buck old trends, look for new color palettes to scrapbook favorite occasions.

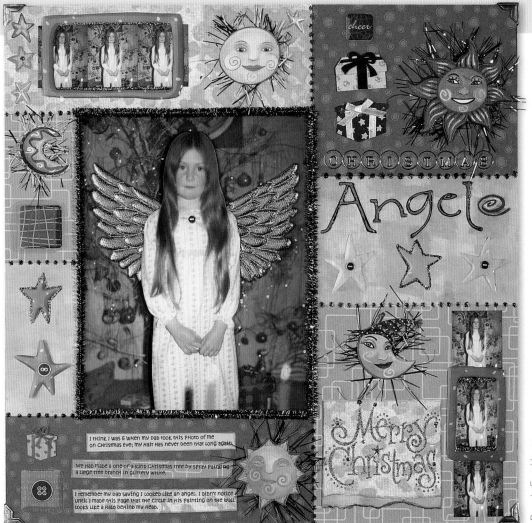

Pamela Frye Hauer

Angel

Orange, green and blue patterned papers are seamed with glitter dots and decorated with holiday stickers to form a canvas for this spectacular Christmas photo. The silhouetted child is popped off the background to make room for gilded angel wings. A glittery title and holiday tinsel further brighten up the page.

DID YOU KNOW...

Before the traditional Chinese New Year's feast, families seal their doors with strips of red paper to keep out bad spirits.

As part of the Nigerian festival of Eyo Masquerade, families may send out an Eyo—a magical being dressed all in white. When confronted by the Eyo, people must show respect by removing their shoes and hats.

The Indian holiday of Holi, which welcomes the arrival of spring, is celebrated by throwing colored powder and balloons filled with colored water.

Thanksgiving

Polka-dot patterned paper, glittery blue papers and teal cardstock contribute to this happy-go-lucky layout. The hand-journaled border is dabbed with colored paints, and the title letters are stamped over spray painted cardstock blocks.

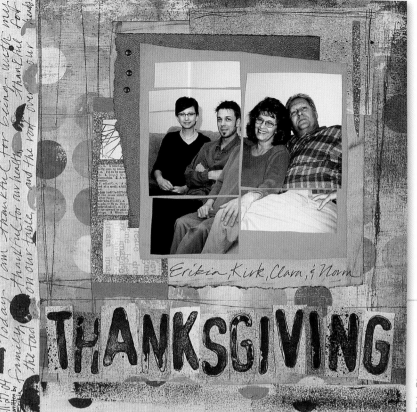

Erikia Ghumm

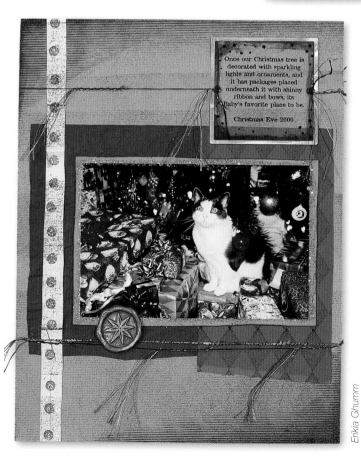

Once our Christmas tree is decorated with sparkling lights and ornaments, and it has packages placed underneath it with shinny ribbon and bows, its Baby's favorite place to be.

Christmas Eve 2000

Erikia Ghumm

STROKE OF GENIUS Manufactured script patterned paper can be beautiful for page borders, but by creating the script paper at home you imprint the scrapbook page with another element of your unique personality. Handwriting says as much about the journalist as the words penned on the page.

Christmas Eve 2000

Burgundy inked brown textured paper is overlaid with stamped pink and crumbled purple paper blocks on this celebratory page. A teal photo mat and glittery lime green paper strip introduce even more flavor to the colorful layout. A painted transparency provides a journaling block, and a clay star graces the bottom edge of the photo.

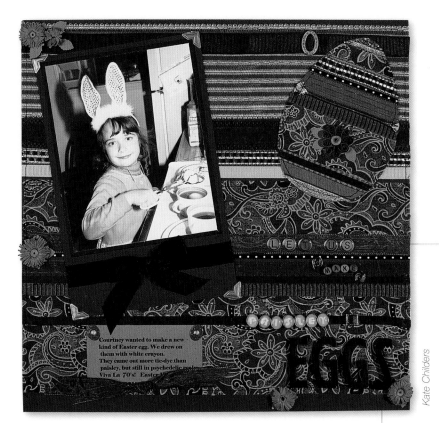

Let's Make Paisley Eggs

Nontraditional colors are used on this enchanting Easter page. The lush background is created with strips of rich paisley fabric and assorted ribbons, mounted on a burgundy cardstock. The egg embellishment, decorated with a quilled flower and glittery tip, fringed flowers, beads, wire, typewriter keys and buckles does nothing to detract from the palette. A black-and-white photo double-mounted on a solid platform of black and burgundy cardstocks provides a resting point for the eyes.

Kate Childers

AH-HA! Fabric is simple to sew to a cardstock background, but ribbons can be a bit more tricky. For fail-safe mounting, run ribbons through an adhesive application machine and apply to the page.

Dirty Dozen

Layered strips of patterned and inked papers and russet colored tabs create an earthy palette for this Easter page. A pale blue photo mat gives a nod to the holiday's traditional pastel theme colors, as do the polka dots within the paper patterns. Colored ribbons and a creative title contribute to the success of the page.

AH-HA! Create a very different look for your page title by printing directly on a transparency and then covering the printed word with letter stickers.

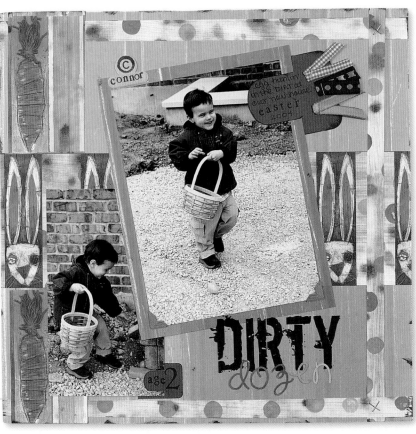

Jeniece Higgins

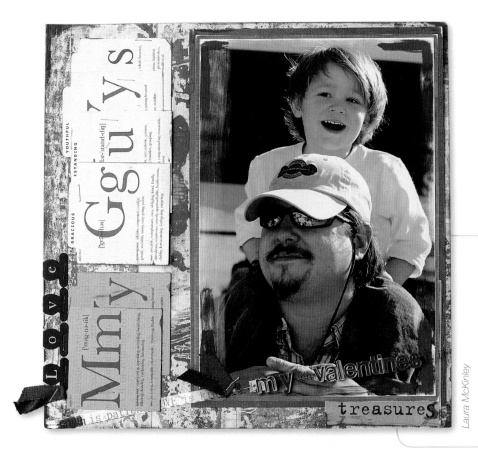

Laura McKinley

My Guys, My Valentines

Red and earth toned patterned papers and cardstock work perfectly to create this Valentine's Day page that gives a nod to the traditional holiday's theme colors while conveying an unmistakably masculine feeling. The photo shares focus with a creative title made of file folders, index tabs and a creative transparency strip and ribbon slide letters.

AH-HA! Create a unique ribbon title border with a strip of transparency. Paint words on a transparency strip, slide on metal letters, and add staples between them to prevent the letters from shifting.

My Funny Valentines

Torn and layered strips of patterned papers surround a sepia photo on this unusual Valentine page. Baby blue paint creates a photo mat, and a thick blue ribbon and patterned paper share the hue. Delicate stitching around select portions of page elements adds a decorative touch, and a paper heart adorned with a stick pin and ribbon complete the page.

AH-HA! A unique heart embellishment is easy to make. Begin by painting a heart shape on a transparency. Cut out the shape and stamp on top of the transparency in an accent color. Slide a stick pin through the paper and tie a delicate bow.

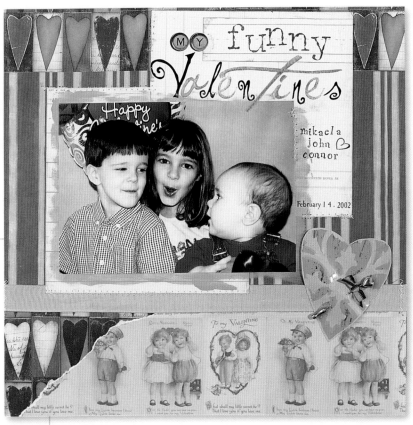

Jeniece Higgins

Back to Mother Earth
warming up to brown, gold and unusual earth tones

Rich fistfuls of freshly turned soil

Autumn leaves crunching under woolen-socked, booted feet

A clay pot baking in the sun

The purple crevices of a mountain's dusk face

Organic

earth

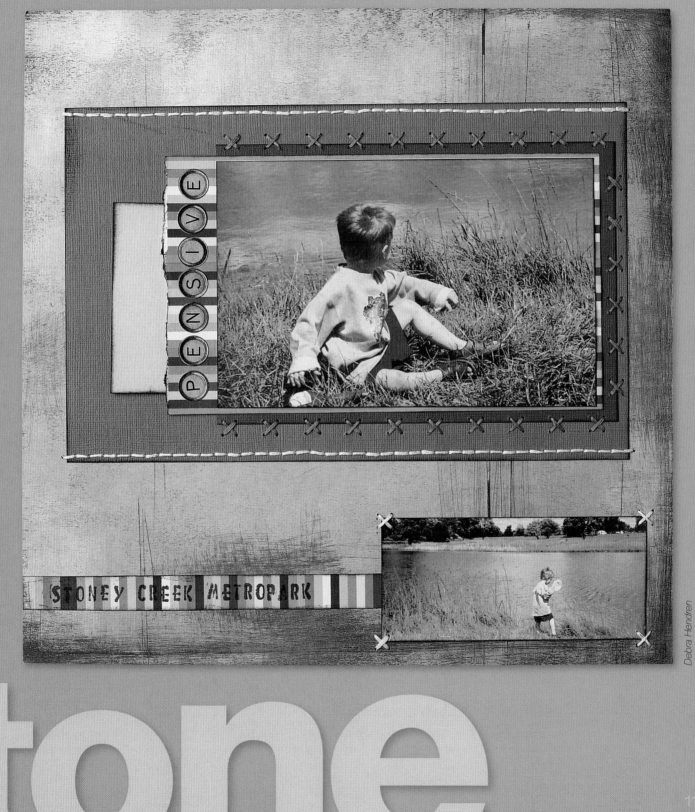

PENSIVE

STONEY CREEK METROPARK

Debra Hendren

tone

Dig the Colors of Nature

While our heads may snap and our hearts may lift at the sight of a field of vibrantly colored wild flowers, the rich soils in which they grow are equally beautiful, as are the polished sheens of browns and golds, of burgundies and bricks, of glowing oak, rich walnut and lustrous cherry wood. Beyond these hues lie the purples of the desert and the greens of plant life, which add to the astounding breadth of options of an earth tone palette. It is for these reasons that scrapbooking with earth tone colors often results in scrapbook pages that are both grounded and glorious.

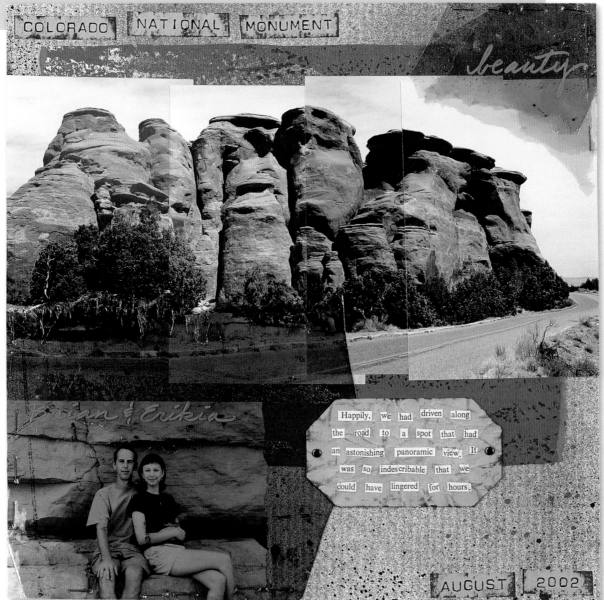

Erika Ghumm

Colorado National Monument

Fiery shades of orange and brown ignite this earth tone page, which showcases a pieced mountain panorama. Handmade background paper, created with spray inks, is topped with iridescent metallic paper, mica and photos. The sky-blue journaling tag sports a message snipped from a vintage book and rearranged. Bright red brads supply a spot of vibrant fun.

What Cha Doing?

A golden moment in a child's life—catching rain in the palm of a hand—is reflected in the glowing gold tones of the printed papers and sepia photo on this earth tone page. A title, ripped from patterned paper, is inked around the edges, while a Dymo journaling strip extends across the bottom of the page. The close-up photo of the child's hand, framed in black, is treated with clear gloss to appear like rain.

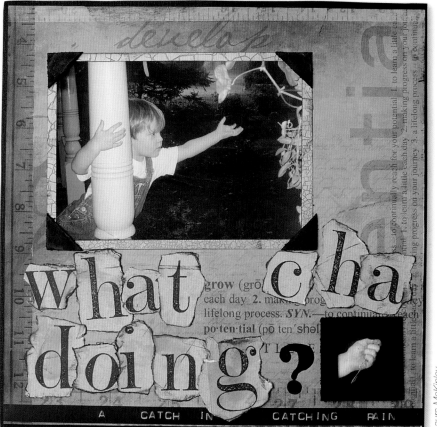

Laura McKinley

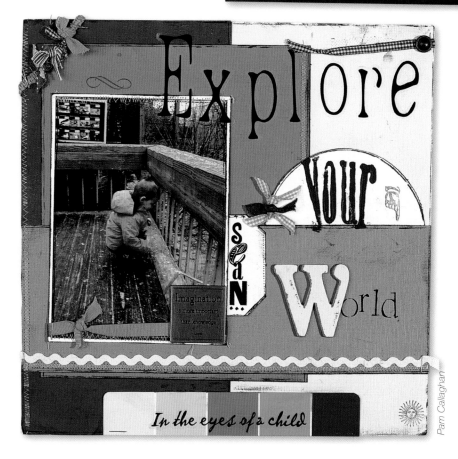

Pam Callaghan

Explore Your World

A paint chip defines the colors for this earth tone page made with varied shades of inked and stitched cardstock blocks. A stamped title stalks across the photo and onto the pieced background. Ribbons, stamped images and an "imagination" phrase plaque lend their own textures and dimensions to this adventurous layout.

Scrapbook Sun-Warmed Earth Tones

Glowing sun-licked earth tones rely on root colors of golds and yellows for their hue. Warmer than other shades of brown, russet, and orange, this palette is as inviting as a sun-warmed rock. Golden earth tones can be used to create scrapbook pages that are emotionally satisfying and comforting.

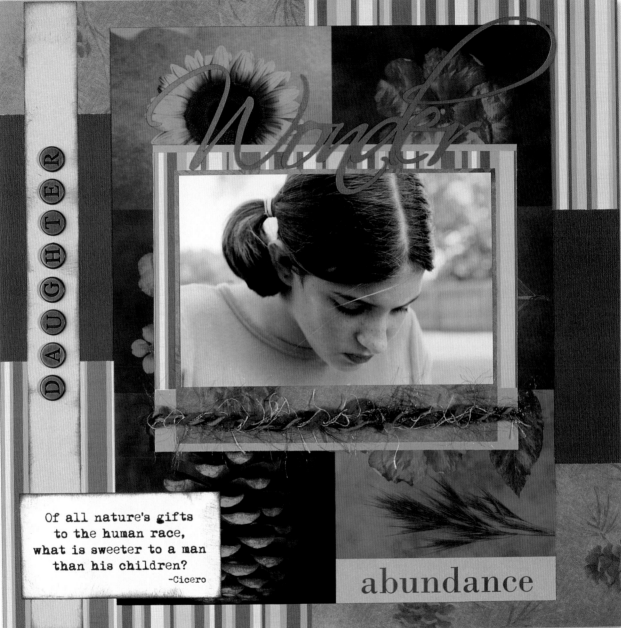

Of all nature's gifts
to the human race,
what is sweeter to a man
than his children?
-Cicero

The Abundance of Life

Patterned paper blocks adhered to brown textured cardstock and a botanical transparency mounted on gold cardstock form the base for this stunning page. The copper color in the scripted title further reflects the glow of the metallic circles which spell "daughter." Fuzzy fibers, strung across the lower edge of the photo mat, add texture, and a poetic quote pulls the page together.

Beautiful Fall

Gleaming earth tone patterned papers hold a dyed crocheted lace strip, paint chips and an assortment of embellishments on this autumn page. The title strides the background papers, uniting the page elements. A delicate stamped leaf decorates a photo corner and tag. Jump rings, safety pins, flower brads and a metal letter, as well as ribbons and flowers, finish the layout in style.

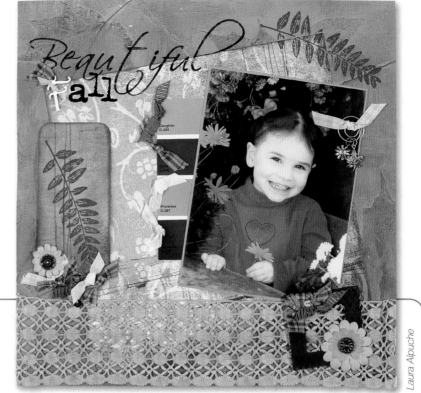

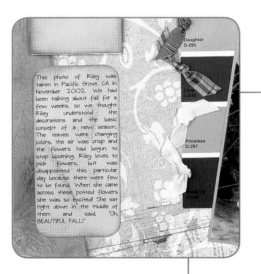

Laura Alpuche

AH-HA! The photo, taken in the fall, didn't originally sing with fall colors. The model's shirt was pink, and the flowers were varieties not often found during cold weather seasons. In order to work more comfortably with the autumn theme, the photo was converted to sepia and the flowers were colorized to add an appropriate complementary splash.

Bring on the Sun

Three different earth tone patterned papers dictate the palette for this summery page. Mesh, a multitude of blue ribbons and a burnished bookplate add embellishment, while typed and journaled tags supply important facts and memories.

Kaleigh Dees

STROKE OF GENIUS! The blue in the child's shorts and towel, along with the poolside theme, might have dictated a more traditional palette treatment in blues and beach-ball colors. The choice of earth tones actually makes the photo more energetic.

Mold with Red Clay Colors

Rich clay reds stride the line between earth and flame, introducing a palette as fascinating as an evening bonfire. These warm ruddy browns are perfect for outdoor pages as well as masculine themes and some holiday pages. Use this earth tone to create pages that are embracing and exciting.

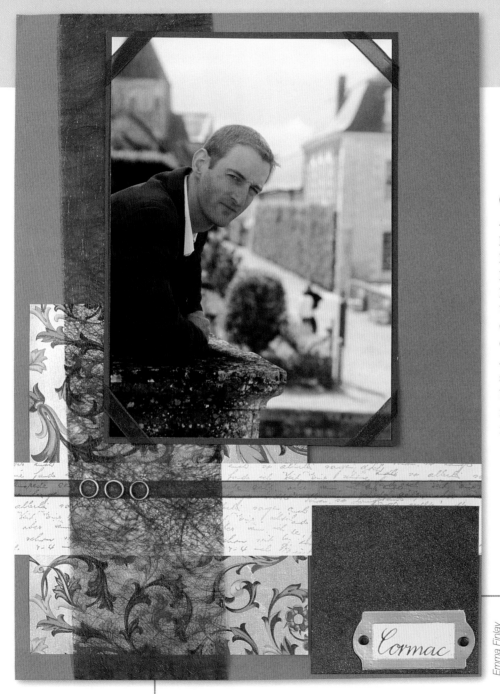

Emma Finlay

Cormac

An ingenious combination of patterned metallic wrapping paper, cardstock, specialty paper and hand-stamped script papers come together to form this beautiful page. Transparent ribbons serve as photo corners and embellishments. A hand-lettered page title set inside a bookplate is both readable and dramatic, mounted on top of a solid metal brown paper block.

AH-HA! Save money by creating a homemade bookplate by embossing the edges of a small block of pale cardstock with copper embossing powder. Leave the center of the bookplate free of powder. Cut out the embossed shape, write in the center and attach to the page with metal brads.

Treythan's Favorite Things

Patterned paper mounted on inked red cardstock makes this double-matted photo pop off the page. Journaling strips embellished with multicolored ribbons, brads, safety pins, paper clips and snaps record the highlights of being two years old. A bold letter "T" cut from patterned paper creates a bold title treatment.

My Girl

Numerous layers of mix-and-matched patterned papers and rich earth tone cardstock form the base for this compelling page. Inked and distressed brads and a journaling label as well as a silk flower add a dimensional look to the page, while ribbons introduce yet another pattern.

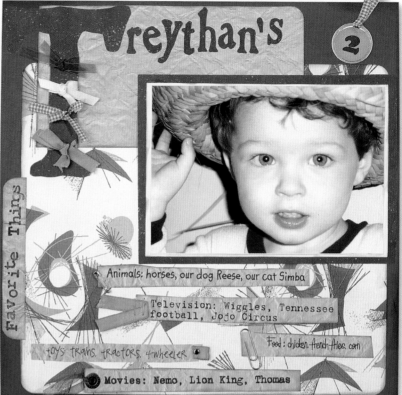

Animals: horses, our dog Reese, our cat Simba

Television: Wiggles, Tennessee football, JoJo Circus

toys: trains, tractors, 4-wheeler

Food: chicken-french-fries, corn

Movies: Nemo, Lion King, Thomas

Tanya Collins Beaty

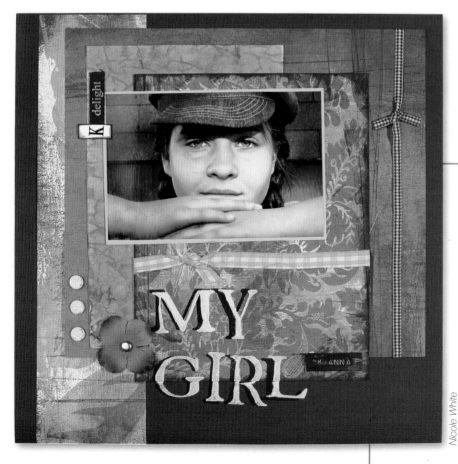

K delight

MY GIRL

KIANNA

Nicole White

 AH-HA! Blue, the dominant color in the photo, does not appear in the papers or embellishments used on this page although the colors of those supplies complement the denim hat. Because the denim blue appears only in the photo, it demands attention, rather than being diluted by other blue elements.

Use Slate, the Other Earth Tone

Beyond brown and gold there exists a variety of less recognized earth tones waiting to take their places on scrapbook pages. They draw their colors from craggy mountain faces, rock fissures and the shaded nooks and crannies of landscape. Use these colors for arresting scrapbook pages that are unusually distinct. Begin to see Mother Earth's possibilities by scrapbooking with sturdy slate.

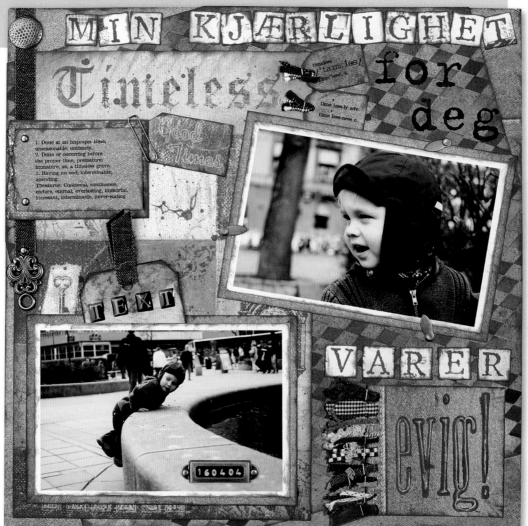

Kjersti Bakken

My Love for You Lasts Forever

A dollop of blue and a dash of gray equals slate, an earth tone that speaks of a winter day in Norway. Inked brown patterned and solid blue papers are pieced at angles to form the page's background. Inking is carried to the stamped title, journaling blocks and photo mats. More than six different patterned ribbons decorate tags, while metallic embellishments introduce a touch of wintery shine.

Preserving History

Seldom in history have sheets of slate stone been so carefully preserved as the two slate blackboards discovered at a New York City firehouse after September 11, 2001. The boards contain the hastily written names of thirteen men who raced off to the World Trade Center after planes crashed into the structure. Nine of the firefighters never returned. The boards, used to denote each firefighter's duties for the day, have been carefully preserved by experts from the Metropolitan Museum of Art. The hope is that as long as the chalked names remain readable, the heroic acts of those who gave their lives will be written in stone—on stone—and never be forgotten.

Maestro

Slate is paired with more traditional earth tones on this page, which manages to hit just the right notes. The photo was double mounted and stitched over the paper-pieced background and ribbon. Mini black brads, copper staples, stickers and a sturdy title of black and domed typewriter keys bring the masterpiece home.

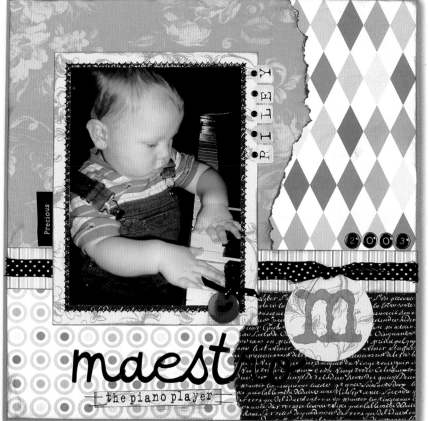

Linda Beeson

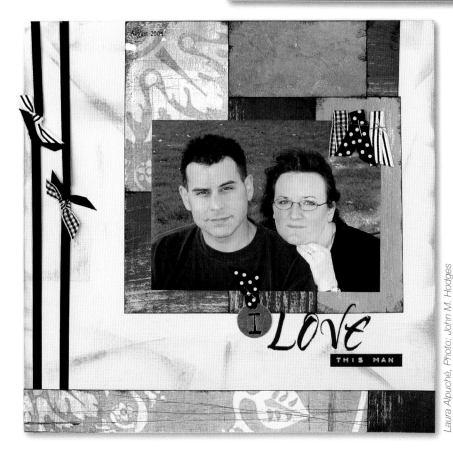

Laura Alpuché, Photo: John M. Hodges

I Love This Man

A color blocked and inked background introduces the slate and tan palette for this page. Black ribbons and a title created from a metal tag, stickers and a Dymo label complete the layout.

Wise Up to Sage Earth Tones

Not mossy, not grassy and definitely not limey, sage walks the line between green and gray. This cool earth tone is perfect for scrapbooking both outdoor and indoor moments. Sage is gentle enough to use with other earth tones and important enough to hold its own with primaries.

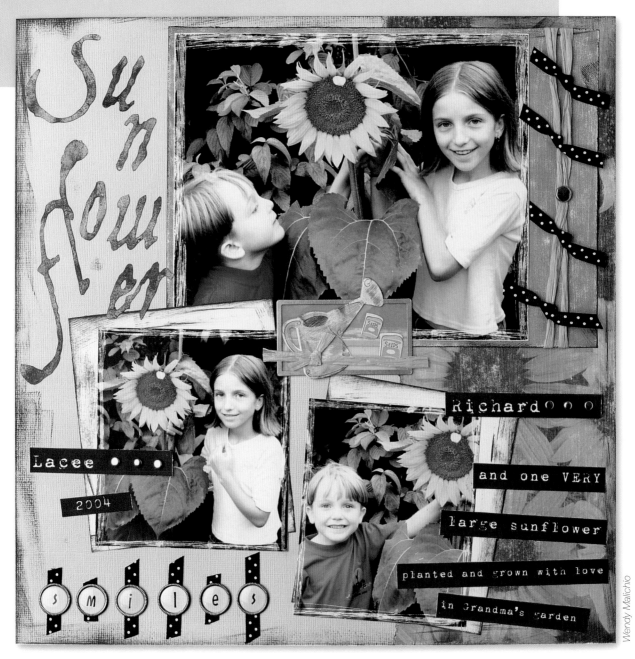

Sunflower Smiles

Textured sage green cardstock and floral patterned papers create the palette for this sunny page. Inking and etching the edges of paper and photos lends a distressed look to the page. Black ribbons, journaling strips and white word pebbles, a hand-cut title and a clever tag decorated with a watering can and seed packet ground the center of the page.

Zachary

There is nothing distressing about this darling page that draws some of its rustic charm from the distressing and inking of its papers. A deep sage background supports layers of patterned paper and a sepia photo. Brads, a decorative journaling tag, fibers and a shiny buckle contribute to the mood of the page.

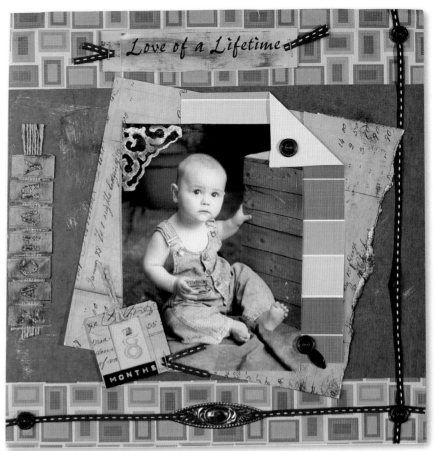

Maredyth Dray, Photo: Images by Paulo

Saurna Island

A design stamped in sage on sage cheese-cloth is laid over a creamy cardstock to form the palette for this earthy page. A bold title printed on a transparency, journaled information on ripped sage blocks, a stamped and inked metal-rimmed tag, rub-ons and typewriter keys supply journaled information. Snaps on twill ribbon, metal swirls and pins complete the layout.

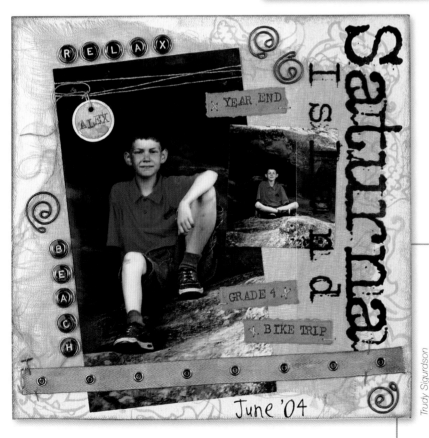

Trudy Sigurdson

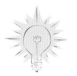

STROKE OF GENIUS Create your own realistic looking typewriter letters by adding typewriter letters to metal washers. Cover with clear gloss and attach to your page.

Surprise with Purple and Pink Earth Tones

Gentle shades of purple and pink bring to mind the evening face of a mountainside. Warm and rich, they can be combined with more traditional earth tones to create pages that feel grounded. Ink or otherwise distress purple and pink papers to root them more deeply on landscape palettes.

Mother and Child

Earthy purples are used to create an atmosphere that is intimate and loving on this mother-child page. Brown and purple patterned papers are layered and stitched to form a background, and a sepia photo captures a sense of warmth. Vintage baby labels, clips, staples and a burgundy gingham ribbon add decorative touches.

> **AH-HA!** If your embellishments do not match your page, paint them with acrylics or other colorants. The rickrack, letter charms, flower eyelets and outer photo edge have all been painted purple to match the background shade.

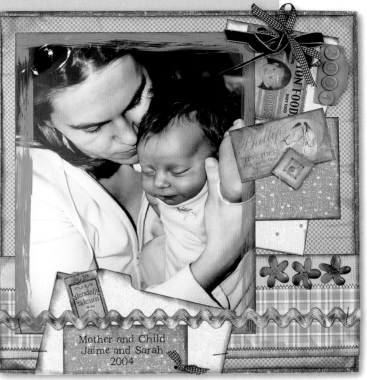

Angela Moen

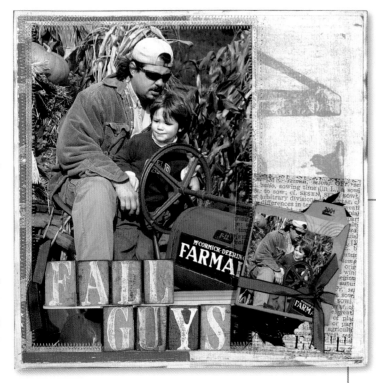

Laura McKinley

Fall Guys

An autumn farm page draws its earth tones from shades of purple. The edges of the printed gray-purple background paper are inked purple to correspond with the stamped purple title blocks. A manipulated black-and-white photo is sewn to the background. Bright orange pumpkins and a journaling envelope juice up the palette.

> **STROKE OF GENIUS** To pull a page together, digitally manipulate the focal photo and print it in black-and-white, colorizing select elements within the shot. Use the original color print as a supporting image. Mount it on a color that relates to one selected for the focal picture.

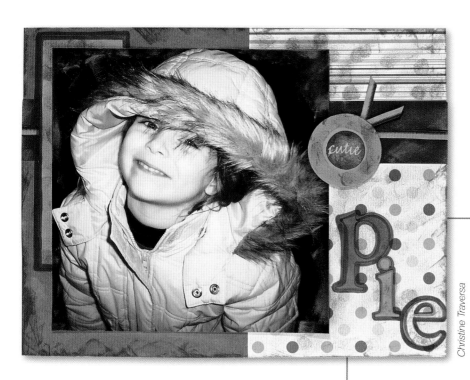

Christine Traversa

Cutie Pie

Inked patterned paper blocks adhered to a brown cardstock background create the foundation for this charming photo. The photo is printed in sepia tones which appear to have pink undertones. The edges of the title letters are colored with a burgundy pen that matches the punched pink circle and "cutie" accent.

AH-HA! Polka dots are added to the striped patterned paper in the upper right corner of the artwork by dipping a finger in ink and pressing firmly on the page. The dotted paper mirrors the pattern in the paper directly below, tying the page design together.

The Best Friend I Never Had

A collection of unusual earth tones come together on this friendly page. Layered and pieced papers include pink, green, brown, purple and cream. Alphabet stickers and rub-ons form the title. A ribbon sling, held in place with brads, metal rings and safety pins, holds cards.

AH-HA! A tiny brown handmade book provides a restful spot for the eyes on this beautiful, busy page. Inside, is detailed the story of a special online friendship that resulted in the collection of creative cards displayed on the page.

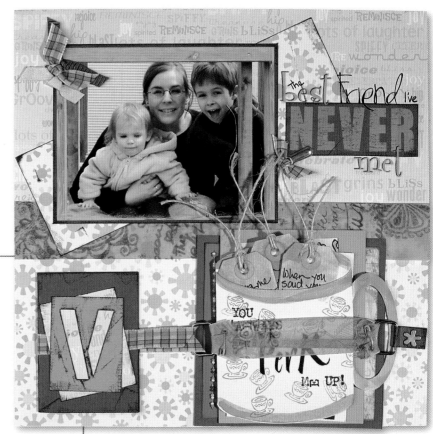

Laura Alpuché, Photo: John Fowler II

Play with the Black Earth

Fashion conscious women know that a combination of black and brown is classy enough to wear year round, although the warmth of the earth tones often make it a fall favorite. Couple the color union with clean lines and perhaps add a vibrant accessory, and you're in business.

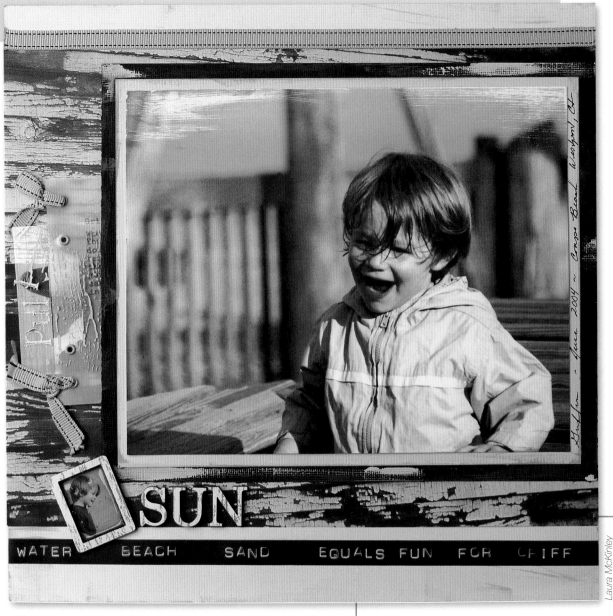

Sun

Patterned paper that mimics the wooden quality of the deck seen in the photo is mounted over cream cardstock to form the platform for a triple-matted photo. The dynamic photo is distressed for a more rustic seaside effect, while other page elements are inked to age them. Blue mini eyelets attach a transparency to a journaling tag, which can be slipped under the left side of the photo.

AH-HA! Dilute blue acrylic paint and sprinkle it across the journaling transparency to look like water for a seaside, rainy day or pool play time theme.

Cute with a Cherry on Top

Earth tone patterned papers introduce black into the landscape of this digitally created page. The black photo frame and the "with" journaling block reinforce the interesting color combination. A screened back black-and-white primary photo is used as background paper for other page elements

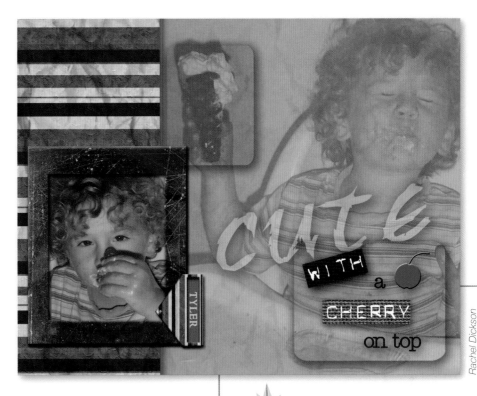

Rachel Dickson

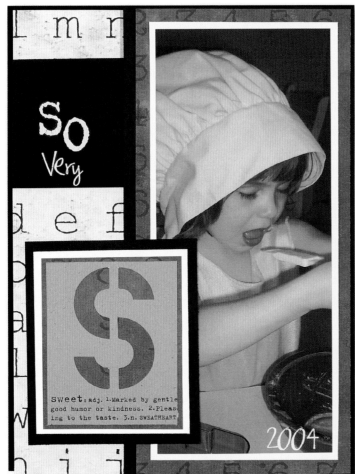

Christine Traversa

STROKE OF GENIUS The bright red cherry on the title block, mirrors the fruit held by the model in the framed photo. Without these vibrant accents the page might be too monotone to work.

So Very Sweet

A palette of black, brown and cream creates a page as warm as freshly baked cookies. A double-matted sepia photo draws the eye. Rub-on letters create a portion of the page title while the "S" letter stencil, triple matted on a collection of patterned paper and cardstocks, completes the title phrase.

125

Inject Excitement onto Earth Tone Pages

Without appropriate care, earth tone pages can appear so laid back that they become visually uninteresting. Prevent this by injecting shots of vibrant color to keep your earth tone spreads lively and energetic. Use photos that contribute powerful and colorful accents or incorporate shots of colorful page elements or embellishment into your earth tone layouts.

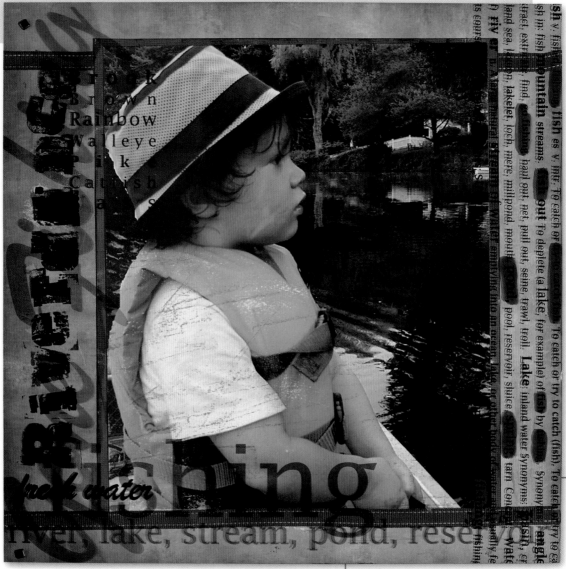

Laura McKinley

River Dance

Warm earth tone papers, ranging from browns to russet reds and musty grays, coupled with printed transparencies, set the tone for this terrific page. Back-to-nature words reinforce the outdoor theme. Stitched ribbons support the page design without competing with the model for attention.

AH-HA! Call upon a vibrant color in your photo to bring excitement to your earth tone spread. The brilliant yellow of the model's life jacket ignites the pages. Without it, the spread would not have the same vitality.

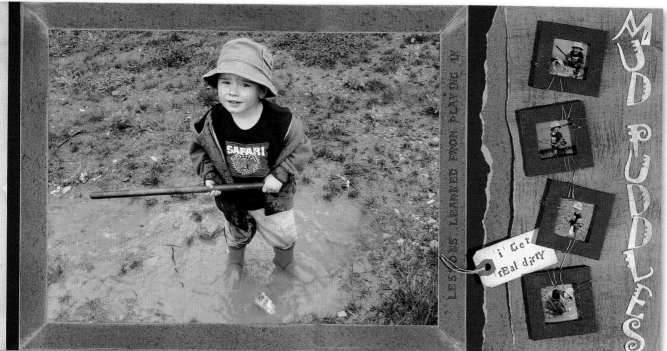

RAIN RAIN GO AWAY LEAVE ME A PUDDLE SO I CAN PLAY

LESSONS LEARNED FROM PLAYING IN

MUD PUDDLES

i' Get rEal dirty

Cindy Smith

STROKE OF GENIUS

Create frames that carry on the "muddy" theme of the spread by painting square slide mount frames with textured brown paint. When dry, wrap them with wire and mount them over photos.

Mud Puddles

Brown patterned cardstocks are layered over a textured cardstock background and used to frame a spectacular photo on this earth tone spread. Supporting photos on the right page are featured in wire-wrapped frames. Walnut-ink, dyed and printed twill ribbon, and inked and distressed title letters and a journaling tag carry forward the "down in the dirt" mood of the page.

Earth Tone Pigments of the Past

Have you ever noticed that many paintings by old masters such as Leonardo and Caravaggio are dominated by brown? That is because the most available pigments to the old masters were literally "from the earth." Many pigments were, and still are, made of clay, soil and even peat. One brown pigment called "Mummy" or "Egyptian Brown" actually came from ground mummy remains. Standard earth tone pigments such as umber and sienna are made of iron-rich clay. And the pigment Burnt Sienna was made by roasting the clay.

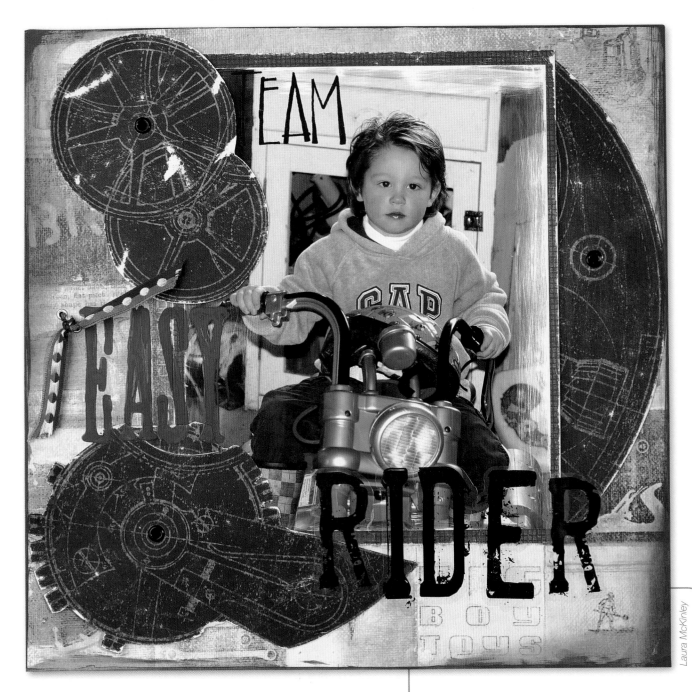

Easy Rider

A neutral aged brown and black patterned cardstock foundation is enhanced with a hint of nontraditional orange and purple painted earth tones pulled from the photo. A mix of rub-ons, paint and rustic stickers create the title, while the sanding techniques throughout play up a rough and tough, boyish feel. Cut-out objects from patterned black paper are attached with eyelets to accent the action of the photo.

 AH-HA! Watering down acrylic paint helps achieve a much softer look when applied on the edge of cardstock to distress or highlight and when used in conjunction with foam stamps.

September

A selection of earth tone patterned papers finds a home on pale golden and purple card-stocks. Pink and orange winged dragonflies seem to arbitrarily flit through the layout, sharing their unique palettes as they go. A layered photo mat of primary red, acidic green, blue, black and brown, along with bright green and purple tags positioned under mica chips, give the page an energy that makes it truly special.

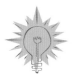

STROKE OF GENIUS An earth tone page, journaling about "strength," the cut-off shorts worn by the model and her pose in the photo (top right corner), all contribute to what might be construed as a "masculine" page. However, the rhinestone "earrings" holding the journaling blocks and mica chips in place, clearly state that this page is a testament to female power.

Sarah Fishburn

My Somber Cowgirl

Inked patterned cowboy-themed paper is stitched to cardstock on this ride-em'-cowgirl earth tone page. A flash of primary colors brings the layout to life. A bright blue envelope bears the page title and holds a matted photo of the model. Brightly colored paper flowers and ribbons further spice up the delightful page.

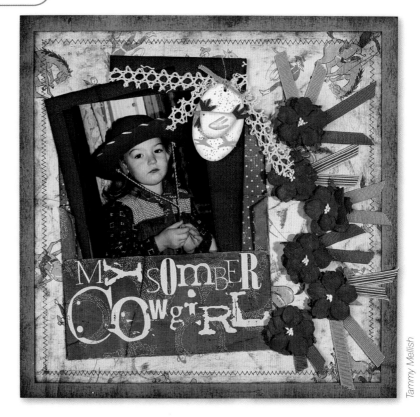

Tammy Mellish

Let Metal Bring Life to Earth Tone Pages

The glow of metal has lured men across continents and to the bottom of the sea. While metal has been a part of this Earth since the beginning of time, it has taken us thousands of years to identify the 86 known types of metal. In fact, 62 of the known metals have been discovered since the 19th century. The most popular are inarguably those used to create decorative pieces such as jewelry and artwork. Today, scrapbookers can mine these metals, and display them on scrapbook pages to create artwork as precious as gold.

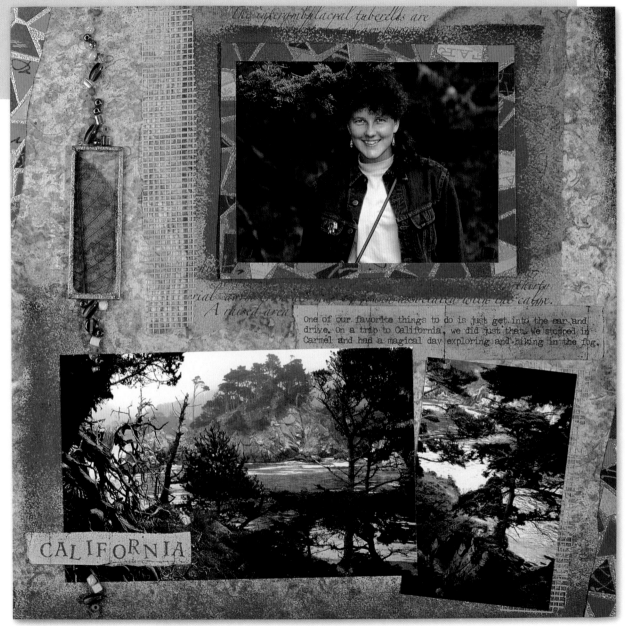

Erikia Ghumm

California

A gold photo mat becomes a complex and stunning piece of art when overlaid with earth tone paper chips. The one-of-a-kind element is repeated in upper and lower page corners. Mesh, a microscope-slide embellishment displaying a skeleton leaf and a necklace of beads add their own elements of gleam and dimension to this back-to-nature page.

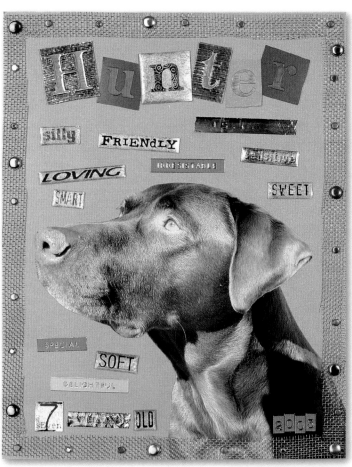

Erikia Ghumm

Hunter

The many shades of metal are showcased on this "ruff-and-ready" page, from burnished bronze to silver, gold and steely mesh. Gold cardstock, epoxy stickers laid atop metallic title and journaling blocks, shiny brads, and gold and silver leafing lend further support to the layout's glow.

Fall Sunset

Painted and torn pieces of colored and metallic cardstocks mounted over an orange textured background capture the magical colors of a fall sunset. Serendipity squares, made of layered, stamped and embossed cardstock, are mounted on ribboned tags and slipped between the torn paper layers. Creative journaling sums up the moment.

 AH-HA! Use copper acrylic paint on cardstock to reflect the glowing sunset palette. Apply the paint with a crumpled plastic bag to achieve a wash of disperse color.

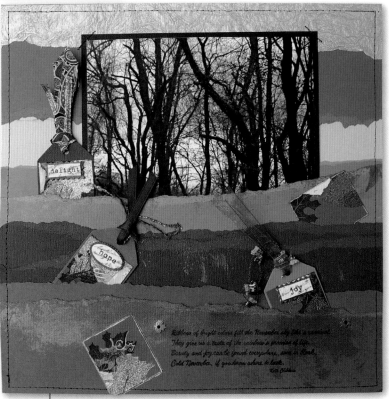

Kate Childers

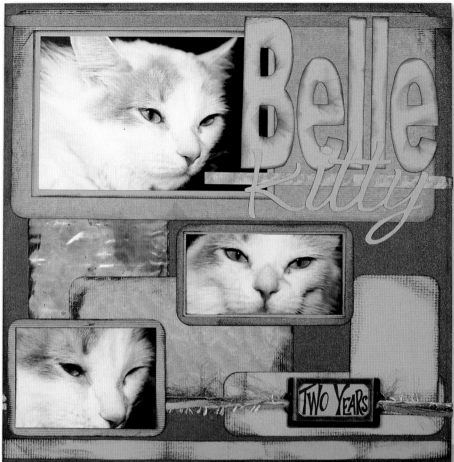

Belle Kitty

A wide variety of metallic papers, a metal bookplate and glittery fibers add a burnished shine to this earth tone page. Inking and layering of page elements, as well as a strong title treatment that overlaps the focal photo and mat, create a cohesive effect.

Cherie Ward

Metal and Mankind

GOLD Early gold varied widely in color because elementary refining methods left behind traces of other metals within the gold. Because gold is both soft and easily manipulated, Stone Age man used it to create jewelry and other ornamental pieces. Later, nuggets of gold were collected from stream beds and hammered together to create jewelry. The arresting color of gold, along with its scarcity, have made the metal one of the most precious in the world.

SILVER Like gold, silver is a favorite metal for ornamental pieces due to its malleability. It is harder than gold, but softer than copper. Silver has been embraced by mankind since early times. In fact, it is mentioned in Genesis. Slag dumps in Asia Minor and on islands in the Aegean Sea indicate that man learned to separate silver from lead as early as 3000 B.C.

COPPER Ancient man found copper a vital metal for tools and weapons. The metal was chipped from the earth and ground into a powder before being formed into tools. Later, it was discovered that copper could be heated and made into thin sheets, which made the material stronger and therefore more useful. While early copper artifacts date back to 3600 B.C. and are thought to have been created in the Nile valley, they were most likely owned solely by nobility. It wasn't until centuries later that average citizens owned tools made of the useful burnished metal.

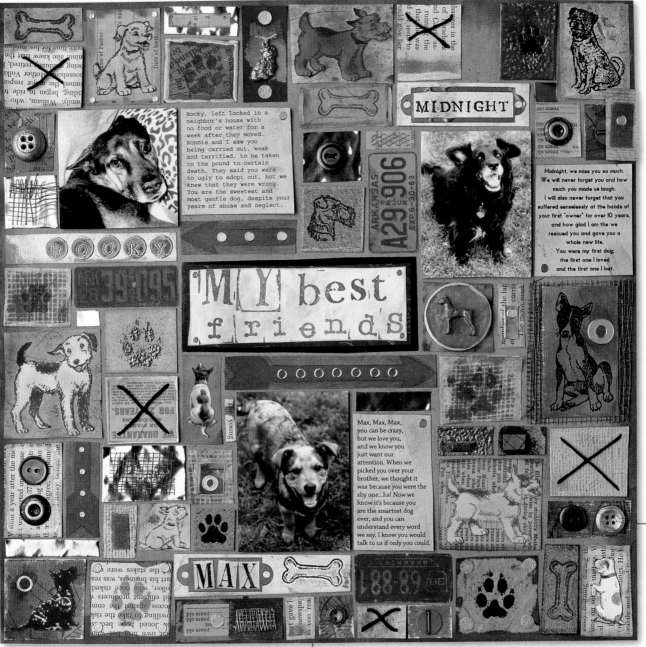

My Best Friend

A pieced puzzle of earth tone patterned papers, photos and ephemera are used to make this knock-your-socks off page. Metallics, including metal frames, letters, mesh, brads, buttons, plates and embossed paw prints, add gleam and richness. Stickers, stitching, clip art and journaling find their places as well.

AH-HA! Create a metallic looking paw print (see directly above) by inking the entire surface of your paper block. Cover it with extra thick copper embossing powder, and heat. While it is still hot, press a paw-print rubber stamp into the powder.

Use Earth Tones to Convey Age

It is a natural process for papers to yellow and brown with age. Colors fade from vibrant to muted. Metals dim. As objects mellow, they turn their backs on their original color palettes and embrace the warmth of earth tones. Use these colors to create stunning scrapbook pages that reflect the irreplaceable value of rare antiques.

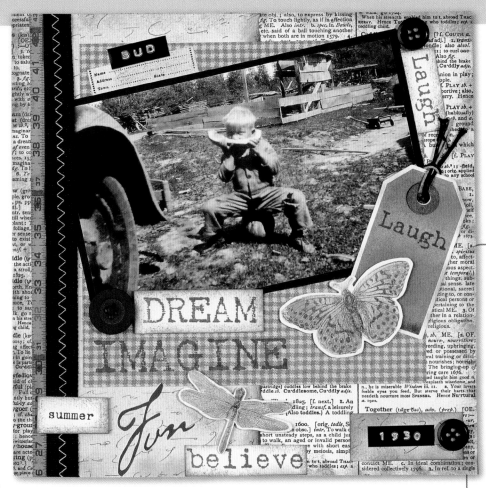

Summer 1930

Inked newspaper print patterned paper works well when layered with other paper patterns, a matted vintage photo, tags and stickers to create this summertime fun page. Black buttons, a Dymo label and a stitched black ribbon offer dramatic contrast to other monochromatic page elements.

AH-HA! Create a beautiful embellishment with butterfly and dragonfly stickers mounted on cardstock and then silhouette cut. A foam dot lifts the flying insects from the page. Position the insects to fly toward, rather than away from, the photos, to draw the viewer's eye to the pictures.

Ramona Lockwood

Preserving Your Photos and Negatives

Stored incorrectly, photos will fade and crack before their time. With a little care, you can protect your photos from premature damage.

- Store photos in photo-safe envelopes that are pH neutral (acid-free) and lignin-free.
- Store photos in sturdy plastic storage systems made of acrylic, polypropylene, polyethylene or polyester.
- Store photos and negatives at temperatures between 65-70 degrees Farenheit and with 30-50 percent humidity.
- Store negatives in negative sleeves, storage binders and boxes that are acid-, lignin-, and PVC-free.
- Separate negative strips with acid-free paper.

Grandpa Bud 1933

Patterned papers, ribbons and an antique sticker offer an aged rusty palette for this compelling heritage page. Brads, photo turns and a Dymo label are used to secure elements to the page.

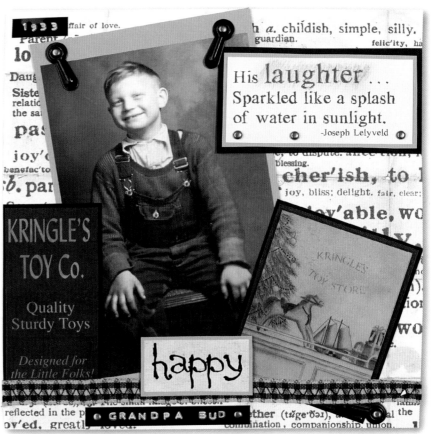

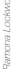

Ramona Lockwood

Love

Peachy patterned vintage papers and a lacy photo border set the scene for this romantic heritage page. The gentle palette conveys a feeling of bygone days and the stamped journaling and phrases speak loudly to the love captured in this wedding photo.

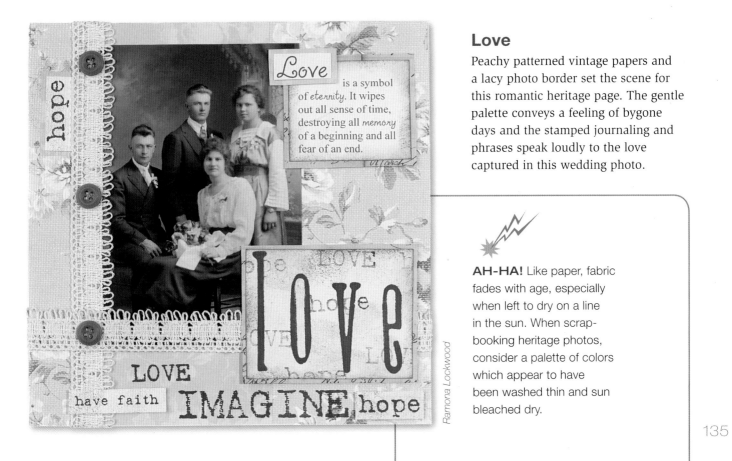

Ramona Lockwood

AH-HA! Like paper, fabric fades with age, especially when left to dry on a line in the sun. When scrapbooking heritage photos, consider a palette of colors which appear to have been washed thin and sun bleached dry.

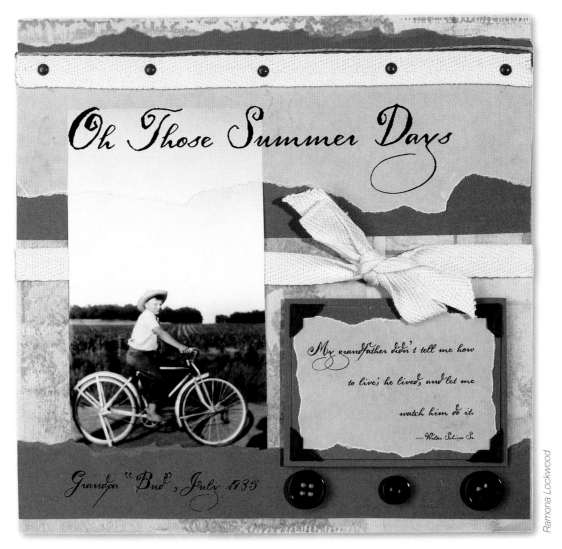

Oh Those Summer Days

My grandfather didn't tell me how to live; he lived, and let me watch him do it.
—Walter Schirra Sr.

Grandpa "Bud", July 1935

Oh Those Summer Days

Unusual earth tone shades of moss and pumpkin join a washed-out silver for this unusual palette. Speckled patterned cardstock and ripped cardstock strips are layered to form the background for this page. The title, lettered on ripped vellum, covers the top half of the photo. A popped up vellum journaling block, mounted with black photo corners and double mounted on pumpkin cardstock, shares a poignant message. Buttons, brads and twine complete the page.

Safe Scrapbooking Supplies

When scrapbooking your heritage photos reach for the products that are most likely to keep the pictures and one-of-a-kind memorabilia from fading or cracking. Here are some guidelines:

- Store photos, memorabilia and paper products in PVC-free holders and containers.

- Use buffered paper products. Paper should be pH neutral and acid- and lignin-free to prevent injury to photos or memorabilia.

- Use photo-safe and acid-free adhesives.

- Do not store photos in magnetic albums with self-adhesive pages.

- Use permanent pigment inks to journal in order to prevent fading or bleeding.

Happy Birthday Stevie

Aged patterned papers mounted on inked and distressed textured brown cardstock create the palette for this birthday page. An aged stencil, stamped title and stamped birthday images utilize the chosen colors. Brads, metallic letters, ribbons and red tiles complete the celebration.

Lily Goldsmith, Photo: Steven Anteen

AH-HA! Birthdays don't have to be scrapbooked in the riotous colors of a bouquet of balloons, as proven by this celebratory page done in earth tones. The inclusion of red carries the festive air, while the brown background and patterned papers speak "vintage."

America...America

Texture, as well as a shot of earth tone and primary colors, are brought together to create this military heritage page made with patterned papers and cardstock. A crumpled paper block offers a stage for journaling. The vintage flag sticker introduces patriotic colors, while the earth tones convey age. Rusty star embellishments, brads and twill tape add decorative touches.

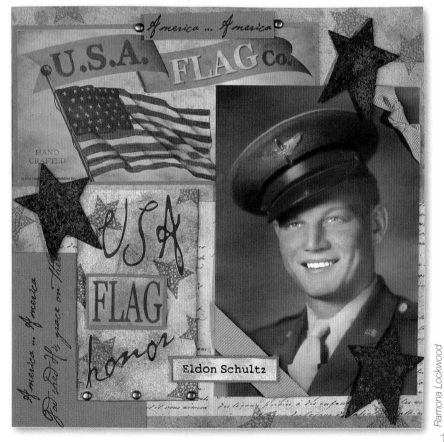

Ramona Lockwood

Work with Unusual Earth Tone Combos

"You mustn't wear white after Labor Day. Simply not done. Nor should you wear brown with black, or purple with pink...or gray under any circumstances if you are younger than 40." Those are the RULES. (Yeah, okay, but we all know that rules were meant to be broken, right?) So break the rules by breaking out the colors and creating scrapbook pages that are so unique even Great Aunt Gertrude will nod in approval.

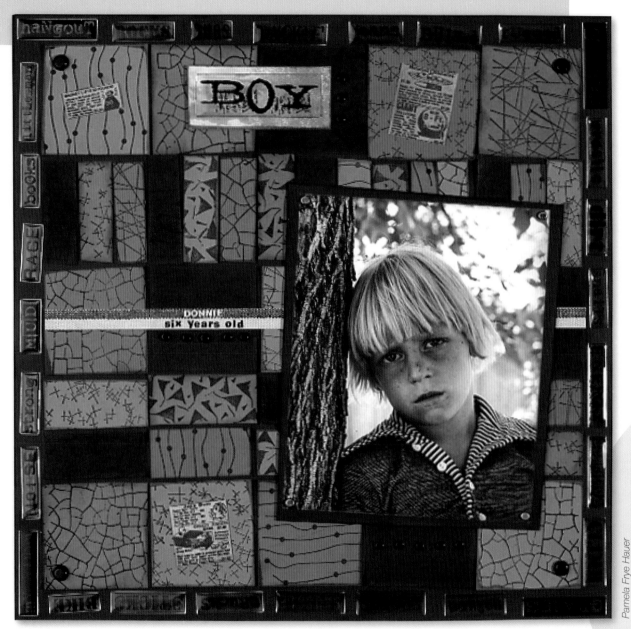

Boy

Turquoise, purple, burgundy and moss inked paper blocks are pieced together to form an unusual—and unusually beautiful— quilted background. Rub-on words, phrase stickers, vintage clippings and black brads add to the dramatic page which showcases a "it's-hard-to-be-six" moment.

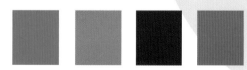

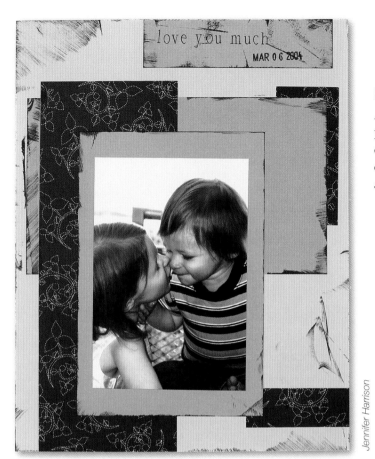

Jennifer Harrison

Love You Much

A collection of vibrant paper scraps pull together to create this exciting earth tone page, that features a compelling black-and-white photo and light inking.

Sunshine

Inked papers in unique colors are offset to form the background for an up-close-and-personal black-and-white photo. Ribbons embellish a supporting photo mat, and brads and a charm add pop.

A simple glance around an overgrown backyard in August or a close look at a mountain meadow will make the point—there are a million greens, and choosing the right one counts. When pairing colors, don't overlook those "odd" and "unusual" hues that make a page truly unique.

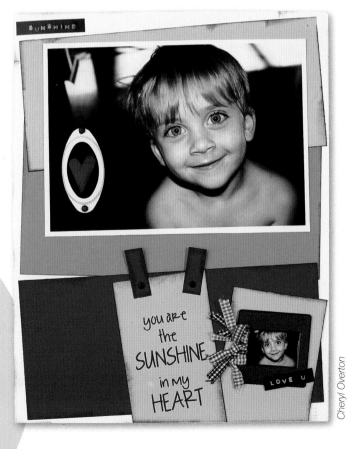

Cheryl Overton

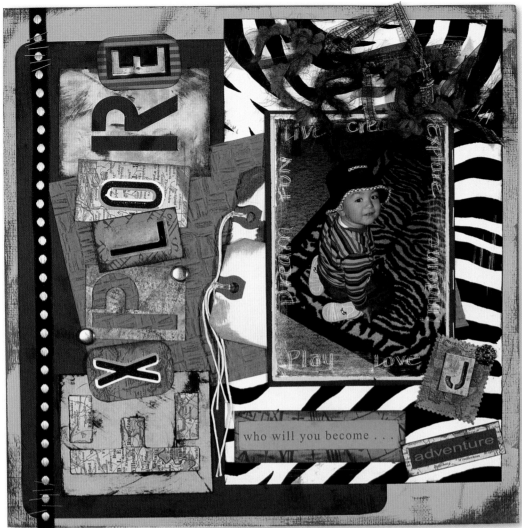

Christina Padilla

Explore

Stencils, stickers, patterned papers, cardstock, colorants, ribbon, twine, tags, staples, brads and metal stencils come together beautifully on this page that is a true visual adventure. Distressing and inking provide a rustic feeling to the earth tone layout. Etched words ride along the edges of the distressed photo, mounted on a raspberry colored mat. A bunch of moss green fibers adds a touch of fuzzy fun.

Odd and Little Known Color Facts

- The human eye can see 7,000,000 colors.

- Blue is an appetite suppressant. Certain weight loss programs encourage dieters to eat from blue plates and to replace white refrigerator bulbs with blue ones.

- People with a condition called "synesthesia" may see colors when they hear particular sounds.

- Seventy-five percent of all pencils are yellow.

- The color pink is a tranquilizer. Sports teams have been known to paint the visitors' locker rooms pink in the hope that their opponents will lose energy.

- Suicides are said to have dropped 34% when London's Blackfriar Bridge was painted green.

- Up until a few years ago, federal regulations stipulated that crash test dummies be dressed in rose-color underwear.

- Seamstresses often refuse to use green thread on the eve of a fashion show for fear it will bring bad luck.

adventurous determined fearless sydney

rock climbing

may 2004

Diana Hudson

Rock Climbing

Vertically cropped photos convey the sense of elevation on this upscale page that draws earth tones from the colors of the rock face. The simple title treatment and minimal journaling support the color palette, but it is ultimately the photos themselves that carry it.

STROKE OF GENIUS When photos feature vibrantly strong colors, allow those shades to define the palette for your page. Support them, but don't undermine them, with the colors of other elements on your page.

Joy

Torn patterned papers in unusual earth tone, black and vibrant accent colors are mounted on a deep raspberry textured background as part of this layout. Red and pale blue paper page corners contribute to the palette, which features an intense black-and-white photo. A ribbon-tied journaling tag is slipped behind the right side of the photo.

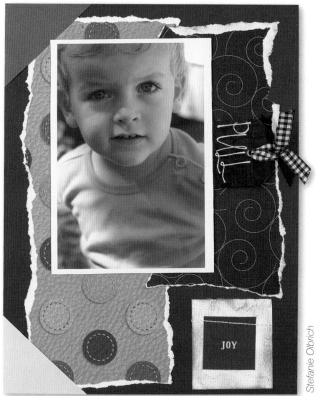

JOY

Stefanie Olbrich

Color Glossary

ACCENT: A contrasting color that adds interest and vibrancy to a scene

ACHROMATIC COLORS: Colors that are viewed as having no saturation and therefore no hue; including black, white and gray

ACIDIC COLORS: Colors that are a bit jarring such as lime green and psychedelic orange and pink

AFTER IMAGES: Ghostly images of a color that you see even after you've looked away

ANALOGOUS COLORS: Colors that are located side by side on the color wheel

BRIGHTNESS: The intensity of the color

CAST: The hint of another color in the color you're working with

CHROMA: The saturation of a color—often used to describe how much gray is in a color

COMPLEMENTARY COLORS: Colors found opposite each other on the color wheel

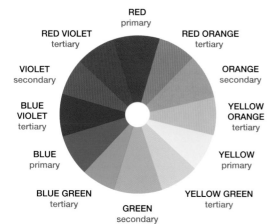

RED
primary

RED VIOLET
tertiary

RED ORANGE
tertiary

VIOLET
secondary

ORANGE
secondary

BLUE VIOLET
tertiary

YELLOW ORANGE
tertiary

BLUE
primary

YELLOW
primary

BLUE GREEN
tertiary

YELLOW GREEN
tertiary

GREEN
secondary

COOL COLORS: Cool colors are often considered to be blue, green and sometimes purple.

EARTH TONES: Colors that might naturally be found in a Southwestern landscape, such as brown, brick and sienna

HOT COLORS: They include red, yellow, orange and pink

HUE: A pure color such as red, yellow, green or blue

IRIDESCENCE: The appearance of spectral colors due to interference of light in thin films such as soap bubbles

LUSTER: The glow, richness and depth of a color

MIDTONES: Colors that fall in the middle, between lightness and darkness

MONOCHROMATIC: A group of colors that fall within the same color range

MUTED: The quality of a color that has lightened or grayed

NEON: An exceptionally bright color such as pink, lime green or screaming yellow

OPALESCENCE: A milky iridescence

OPAQUE: A color that can hide another image beneath it

PATINA: A color that has been discolored due to the effect of the atmosphere

PIGMENT: A coloring material that usually cannot be dissolved in water

PRIMARY: The three basic colors from which all the colors can be mixed—red, yellow and blue

SATURATION: The strength and purity of a color—sometimes spoken of in terms of intensity

SECONDARY: Refers to green, orange or purple, which can be created by mixing primary colors

SHADE: A grayed color

TINT: A color that has been lightened through the addition of white or by being applied very lightly

TONE: A color to which black has been added

TRANSLUCENT: A quality of color that has depth and richness and seems to have undertones

VALUE: The relative lightness of color as determined by the gray scale

WARM COLORS: Considered to include earth tone shades such as brown, gold, deep oranges and deep greens

In this painting the artists uses a rich palette of warm yellows, reds, and greens.

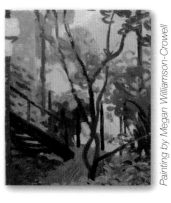

Primary Pop Quiz Answers (from page 45)

1. The term "red handed" comes from the idea that the criminal is caught with the victim's blood still on his hands. 2. The term "paint the town red" is said to come from the kind of high energy escapades that result in injury and may cause bleeding. 3. The color yellow has long been associated with cowardice, just as the belly region is associated with grit and bravery. Therefore, to be "yellow-bellied" would imply that a person lacks courage and character. 4. The term "blue streak" comes from the observation that lightning may look blue as it blazes across the sky, associating that color with speed. 5. The phrase "blue moon" may stem from the observation that during extremely rare events such as volcanic eruptions and strange weather conditions the moon may appear blue. 6. The term "blue-blooded" is thought to refer to European nobility, whose lineage was so pure that their fair skin was transparent enough for blue veins to be seen.

Index